BIOGRAPHICAL MEMOIRS OF EXTRAORDINARY PAINTERS (1780)

William Beckford

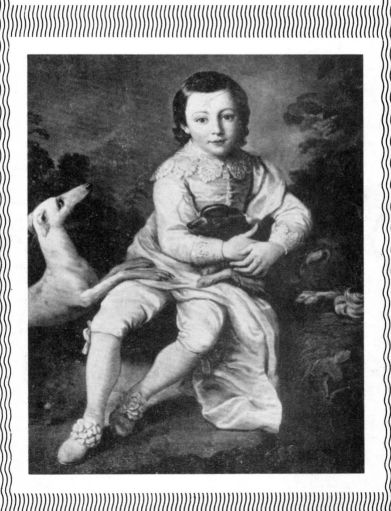

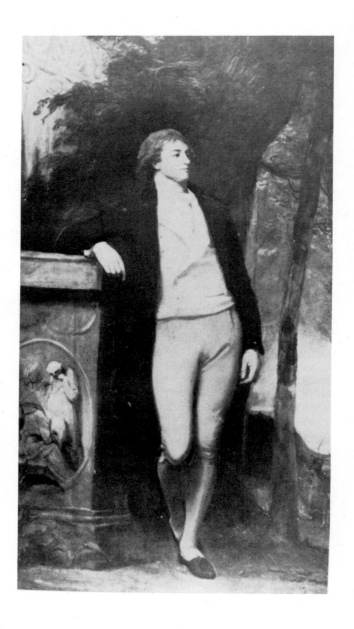

BIOGRAPHICAL MEMOIRS
OF EXTRAORDINARY
PAINTERS
(1780)

William Beckford

with a new introduction by
Philip Ward

THE OLEANDER PRESS

THE OLEANDER PRESS
17 STANSGATE AVENUE
CAMBRIDGE CB2 2QZ
ENGLAND

THE OLEANDER PRESS
210 FIFTH AVENUE
NEW YORK, N.Y. 10010
U.S.A.

ISBN 0 900891 13 0

Printed by
The Burlington Press
Foxton

BIOGRAPHICAL MEMOIRS OF EXTRAORDINARY
PAINTERS

Introduction

William Beckford (1760-1844), known with pardonable exaggeration
since Byron's time as 'England's wealthiest son', takes his place in the
manuals of English literary history on one count only: he wrote the
fantastic 'Arabian' tale *Vathek* (in French, 1786), though the novel we
read today[1] is a translation into English by the Reverend Samuel Hen-
ley from Beckford's French original which appeared in Lausanne later
in 1786 or early in 1787.

Beckford was also a travel writer of exceptional discrimination, pro-
ducing *Dreams, waking thoughts, and incidents* (1783), augmented and
revised as *Italy; with Sketches of Spain and Portugal* (1834); *and
Recollections of an excursion to the monasteries of Alcobaça and Ba-
talha* (1835).

I am therefore perhaps alone in preferring the *Biographical memoirs
of extraordinary painters,* and a reprint of this rare work may require a
word of apology. It first appeared in 1780, was reissued the same year,
and again in 1824 and 1834, so it was a familiar enough book a hun-
dred and fifty years ago, but the present reprint is thought to be the
first since the author's death. Beckford's admiring editor and tutor, the
Reverend John Lettice, states [2] that he is not at liberty to divulge the
age at which the 'memoirs' were written, but hints at a precocity not
unexpected in a boy who claimed to have given, at the age of five, the
eight-year-old Mozart a tune which would emerge in *Le nozze di Fig-
aro* as *'Non più andrai'*. If indeed Beckford was uncharacteristically ac-

[1] "Novela a cuyas últimas diez páginas William Beckford debe su gloria", in the
view of Jorge Luis Borges *(Otras inquisiciones,* Buenos Aires, 1960, p. 188).

[2] 'Advertisement', p.i. Lettice's memory is reviled, for he
"persuaded his pupil to sacrifice a splendid heap of oriental drawings
by burning them", as James Lees-Milne records *(William Beckford,* Tis-
bury, Wilts., 1976, p. 16).

curate in telling Cyrus Redding[3] that he had written the book at the age of seventeen, before leaving England for Geneva (early Summer 1777), this is almost certainly true for only part of the book, or an earlier draft.[4] André Parreaux has every justification for asserting that the definitive text "n'eut lieu qu'en Suisse, ou peut-être même, après son retour de Suisse (en novembre 1778), c'est-à-dire, pratiquement, au cours de l'année 1779 et au début de 1780".[5]

Guy Chapman and John Hodgkin go further, dating *Aldrovandus Magnus, with Andrew Guelph and Og of Basan, Sucrewasser* and *Blunderbussiana* to the Autumn and Winter of 1779 and *Watersouchy* to the Spring of 1780.[6]

Cyrus Redding, in his heavily-censored *Memoirs of William Beckford*, plausibly suggests that the idea for the book might have stemmed from Beckford's amused observation of his housekeeper's explanations of Fonthill paintings to visitors and friends. Her account of the artists, themes, and value of the paintings owed more to fantasy than to research as is usual in such cases, but whereas an average adolescent would smile and shake his head in mock amazement, Beckford the bizarre elaborated these anecdotes into comic tales and parodies of artists and artist-types of his acquaintance, for many of whom he shows no great sympathy.

[3]*Memoirs of William Beckford of Fonthill* (2 vols., 1859, vol. I, p. 96).

[4]R.J. Gemmett, *The composition of Beckford's "Biographical memoirs of extraordinary painters* in *Philological Quarterly,* vol. 47, 1968.

[5]*Les "Peintres extraordinaires" de Beckford: sont-ils une satire des écoles flamande et hollandaise?* in *Revue du Nord,* vol. 43, 1961. I am greatly indebted to Professor Parreaux, author of the invaluable *William Beckford, auteur de "Vathek"* (1960), for his latest views on the book, which were made available to me by personal communication in 1975, nineteen years after this long and important article was written.

[6]*A bibliography of William Beckford of Fonthill* (London, 1930).

Though one cannot help agreeing with André Parreaux that, whatever else the book may be, it is not primarily a *roman à clef,* it is only to be expected that the modern reader will wish to identify the painters here lampooned, much as the perplexed reviewer in *The Monthly Review* (1780, p. 469) attempted to identify them, with no success at all: "we have consulted both professors and virtuosos concerning it, but still remain in the dark with respect to the author's real drift . . . On the first view of this performance, it naturally occurs that the author meant to draw some modern or living characters; but if such was his intention, we confess that we are not of that class of readers who can identify any one of them in this mingled mass of true and fictitious history".

It is unlikely that each of Beckford's characters corresponds to a single real painter, rather than to a school or fashion. It should also be realized that many real painters are introduced (among them Gerrit Dou (1613-1675), Hans Memling[7] (d.1494), Frans van Cuyck van Mierhop (1640-1692), Joseph Porta (1520-1570) known as Salviati il Giovane, and Maria Sibylla Merian (1647-1717). The faint air of blasphemy pervading the work, which will recur until the final page of *Vathek,* is exemplified by the use of the Biblical name 'Og of Basan'[8], and the pervading sense of hoax and mystification by the semi-familiar name 'George Podebrac', which turns out to be the real 'George Podiebrad'. The work was of course never intended as a thoroughgoing hoax, for its burlesque nature is immediately obvious on the opening page, where the Great Aldrovandus is "unanimously" allowed by "the most experienced colourists" of all Europe " to have exceeded [Hubert and Jan van Eyck] in every respect".

[7] The 'Jean Hemmeline' of the *Biographical memoirs,* p.2.

[8] "For only Og king of Bashan remained of the remnant of giants; behold, his bedstead was a bedstead of iron; is it not in Rabbath of the children of Ammon? Nine cubits was the length thereof, and four cubits the breadth of it, after the cubit of a man" — *Deuteronomy,* Ch. 3, xi, in the Authorized Version.

The Victoria and Albert Museum copy of the *Biographical memoirs* bears an attempt at identification by a previous owner. Aldrovandus is there matched with Sir Joshua Reynolds (1723-1742), Og is James Barry (1714-1806), Blunderbussiana is John Hamilton Mortimer (1741-1779), and Watersouchy is Johann Joseph Zauffely (1733-1810), better known in England as John Zoffany. All of these guesses seem wide of the mark, with the possible exception of the Mortimer hypothesis, more particularly in the light of Parreaux' comparison[9] of Beckford's text with his annotations in the Fonthill copy of J.B. Descamps' *Vie des peintres flamands, allemands et hollandois* (4 vols., Paris, 1753-64)[10], a book specifically cited in the *Biographical memoirs*.[11]

The matter is so complex that it is reasonable to view Beckford's satire as in part a parody of the Fonthill housekeeper, in part a *roman à clef*, and in part an attack on biographical compendia such as that by Descamps which Beckford is known to have possessed and plagiarized quite extensively. Similar books used by Beckford include Joachimus de Sandrart's *Academia nobilissimae artis pictoriae* (Nuremberg, 1683), André Félibien's *Entretiens sur les vies et sur les ouvrages des plus excellens peintres et architectes* (3 vols. in 2, Paris, 1690), Arnold Houbraken's *De groote schouburgh der nederlantsche konstschilders en schilderessen* (3 vols., Amsterdam, 1718-21), and Antoine Nicolas Dezallier D'Argenville's *Abrégé de la vie des plus fameux peintres avec le supplément* (3 vols., Paris, 1745-52).

Where Descamps describes Gerrit Dou, for instance, Beckford borrows for his life of Watersouchy such comic trivia as: "He therefore began his pupil's initiation with great alacrity, first teaching him cautiously to

[9] *Les "Peintres extraordinaires . . .", p. 19.*

[10] Beckford Library sale catalogue (1882-3), first portion, lot 2548.

[11] *Biographical memoirs, p. 155 n.*

open the cabinet door, lest any particles of dust should be dislodged and fix upon his canvas, and advising him never to take up his pencil without sitting motionless a few minutes, till every mote casually floating in the air should be settled".[12]

Yet the casual observer should not equate Dou with Watersouchy on the basis of this plagiarism, as the presence of the real Dou elsewhere in the book warns us. Neither is it reasonable to take too literally Parreaux's note on the resemblance between Jean-Daniel Huber (1754-1829, son of Beckford's friend Jean Huber, 1721-1786) and 'Og of Basan'.[13]

The longest story in the book, *Andrew Guelph and Og of Basan*, is also the most serious and the most nearly autobiographical, in the sense that Beckford makes use of his known plans and inclinations. He, like Og of Basan, was a passionate admirer of Ariosto and romantic landscapes; as early as November 1777 he had been actively engaged in drawing up an itinerary of a trip to be made in 1782-3 with John Robert Cozens (1752-99), son of his drawing master Alexander Cozens (c.1717-86).[14] But a similar caveat is entered here: autobiographical elements do not make an autobiography, and neither Andrew nor Og can be said to 'be' either Cozens or Beckford.

Parreaux's conclusion is too categorical: "Nul doute enfin que les *Extraordinary Painters*, sous couleur d'attaquer la peinture hollandaise et flamande, ne visent à ridiculiser celle de Mengs et de son école".[15] The Bohemian Anton Raphael Mengs (1728-79) achieved European renown

[12] *Biographical memoirs,* p. 128, plagiarized almost word-for-word from Descamps, op. cit., vol. II, pp. 217-8. As a matter of interest, in December 1814 Beckford was to buy in Paris the Dou *Poulterer's shop* now in the National Gallery, London.

[13] *Les "Peintres extraordinaires . . .",* p. 24.

[14] *The life and letters of William Beckford of Fonthill,* ed. by Lewis Melville (London, 1910, p. 37). Letter dated 24 November 1777.

[15] *Les "Peintres extraordinaires . . .",* pp. 33-4.

and great wealth through painting the portraits of Prince Charles (later Charles III of Spain) and other members of the royal family during a visit to Naples, and in 1761 went as court painter to Madrid, returning to Italy in 1769 to continue working for Pope Clement XIV. He spent the period 1773-7 in Spain, returning to Italy for the last time in 1777. Mengs' wife died in 1778, whereupon he lost the will to live. As an artist he obtained wider recognition than any of his contemporaries, but his static, even academic style did not impress J.R. Cozens, Jean-Daniel Huber, and the Beckford who was to write *Vathek,* to describe Huber drawings with enthusiasm as "the boldest you ever beheld"[16], and to write of John Martin (1789-1854), "I've been three times running to the Exhibition in Pall Mall to admire *The Capture of Babylon* by Martin. He adds the greatest distinction to contemporary art. Oh what a sublime thing!"[17] The Roman school of Mengs included Jakob-Philipp Hackert (1737-1807) and his less well-known brothers, among them Johann-Gottlieb; it taught the careful representation and imitation of nature and a Teutonic tradition of meticulous detail. Johann-Gottlieb carried out commissions for the first Lady Hamilton, who was to become a close friend and confidante of Beckford.

Parreaux, whose suggestions seem more sensitive to Beckford's psychology than those of earlier commentators who understood the book to satirize contemporary English painters, agrees with the present writer that the *Biographical memoirs* are indeed fundamentally a complex joke. But in his reading the joke is turned chiefly against the English art collectors such as Sir Watkin Williams-Wynne or Sir Thomas Gascoyne who paid exaggerated sums for what Beckford and Cozens

[16] *The collection of autograph letters and historical documents formed by Alfred Morrison,* 2nd ser., 1882-93, vol. I, p. 187.

[17] *Life at Fonthill, 1807-1822,* ed. by Boyd Alexander (London, 1957). Letter dated 5 February 1819 to his lifelong friend Gregorio Franchi (1770-1828).

considered mere exercises in draughtmanship and detail by Mengs, Hackert, and their pupils and hangers-on. Beckford, inspired by Alexander Cozens and by Huber *père et fils,* writes a panegyric on lyrical inspiration that is simultaneously imbued with his eccentric cynicism and glee in mocking - even as obliquely as this — such comfortable high priests of art and fashion as Mengs or Hackert, who had sought and won worldly honour.

A contemporary of the Romantics, Beckford emerges as one of their number, attacking the "laborious high-finishing"[18] of the German School of Rome in a manner characteristically sly. Far from attacking his English contemporaries, as had been assumed by most earlier writers who had given any thought to what is after all a *jeu d'esprit,*[19] the *Biographical memoirs* are probably best interpreted to be at least in part an apology for the Romantic style in art then exemplified by Alexander Cozens. Beckford praises the sketches of Og of Basan for their "boldness of design", while Horace Walpole describes Cozens' landscapes as "bold and very good, bold and masterly".[20] And though one rejects the need to find consistency in a character so thoroughly inconsistent, Beckford himself was to defend the English School openly in the *Travel-Diaries.*[21]

The book's achievement is substantial for a young man publishing in his twentieth year: it is precocious, uneven, often amusing, occasionally thoughtful, and never less than intriguing. Behind the sarcastic wit is a connoisseurship far ahead of the time: no fewer than twenty of

[18] *Memoirs* by Thomas Jones, Walpole Society, 1946-8 (vol. 32, 1951).

[19] See for example the anonymous notice in *Retrospective Review,* vol. X, 1820, pp. 172-9.

[20] *Notes . . . on the Exhibitions of a Society of Artists and the Free Society of Artists, 1769-1791,* Walpole Society, 1939, (vol. 27, p. 64).

[21] *Travel-Diaries of William Beckford of Fonthill,* ed. with a memoir and notes by Guy Chapman (2 vols., London, 1928, vol. I, pp. 260-1).

the paintings collected by Beckford (by Raphael, Bellini, Garofalo, Elsheimer, van der Weyden and others) are now to be found in the National Gallery, London.

Yet at the end of the *Biographical memoirs* one is left with a nagging regret. Beckford was not only one of England's foremost eccentrics, of a literary discernment and imaginative range comparable with those of Carroll or Mervyn Peake: he was also a man of immense wealth.

How fitting it would have been to endow a parallel National Gallery in the heart of Wiltshire with works by such Extraordinary Painters as are here delineated. One would cheerfully surrender a van Goyen or a pair of Corots for his scholarly catalogue of Soorcrout, or an exhibition devoted to the tercentenary of the birth of Insignificanti.

BIBLIOGRAPHICAL NOTE

The edition here reproduced in facsimile is the first impression of 1780, for which the bookseller James Robson paid Beckford fifty pounds. Robson reprinted the anonymous book the same year, changing only the title-page, which now read: "Biographical Memoirs of Extraordinary Painters: Exhibiting Not only Sketches of their principal Works and professional Characters; but a Variety of Romantic Adventures and Original Anecdotes: Interspersed with Picturesque Descriptions of Many New and Singular Scenes, In which they were engaged. Second Edition. London: Printed for J. Robson, New Bond Street. M DCC LXXX." William Clarke (c.1752-1830), Robson's nephew and partner and 'Boletus' of the correspondence, reprinted the book in 1824, and the latest recorded reissue is that of Richard Bentley, in 1834.

The first editions of Beckford's other writings are: *The Vision* (written in 1777-8) and *Liber Veritatis* (written in the 1830s), published together by Guy Chapman (1930); *An excursion to the Grande Chartreuse in the year 1778,* printed in 1783 and collected in *Italy, with Sketches of Spain and Portugal* (1834); *Dreams, waking thoughts, and incidents,* written 1780-3, suppressed on its publication in 1783,

and amended for its reissue as vol. I of *Italy; with Sketches of Spain and Portugal* (1834); *Vathek,* written in French and published anonymously in French (Lausanne, 1786 or early 1787), following the 1786 publication of the Samuel Henley English translation; *Modern novel writing, or the elegant enthusiast,* written under the pen-name Lady Harriet Marlow (1796); *Azemia,* written under the pseudonym J.A.M. Jenks (1797); *Italy, with Sketches of Spain and Portugal* (2 vols., 1834); *Recollections of an excursion to the monasteries of Alcobaça and Batalha in 1794* (1835); and *The Episodes of Vathek,* edited by Lewis Melville (1912).

Boyd Alexander has edited two volumes of the Journals: *The Journal of William Beckford in Portugal and Spain,* written in 1787 and published in 1954; and *Journal of 1794* (1961) and two volumes of the Correspondence: *Life at Fonthill, 1807-1822* (1957) and *England's wealthiest son* (1962).

ICONOGRAPHICAL NOTE

Beckford as a boy, shown on the front and back covers, was probably painted by William Hoare (1706-1792) and is now in the collection of Mrs Lovett West, New York.

Beckford at the age of 21, the year after the *Biographical memoirs* first appeared, was painted by George Romney (1734-1802) and is now in the Bearsted Collection, Upton House, Warwicks. It is shown opposite the new title-page.

Beckford at about 40, shown facing the original title-page, was painted by John Hoppner (1758-1810) and is now in the City Art Gallery, Salford, Lancs.

Permission to reproduce these portraits is acknowledged with thanks.

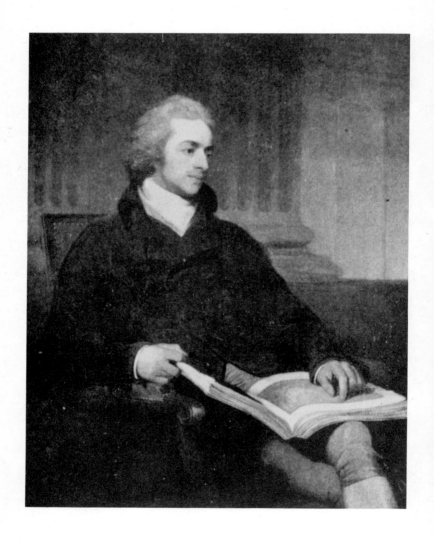

BIOGRAPHICAL MEMOIRS

OF EXTRAORDINARY

P A I N T E R S.

——Λόγος ἐςι ψευδὴς ἐικονίζων ἀλήθειαν.

Aphthonius Progymnas. Pr.

LONDON:

PRINTED FOR J. ROBSON, NEW-BOND-STREET.

MDCCLXXX.

Advertisement.

THE editor of the following pieces is in possession of some particulars relative to the author, which, he has reason to think, might interest the curiosity of a respectable class of readers, and even prepossess them in favour of the publication. As, however, an impartial judgment on its merits is wished for, and the editor's availing himself of such an advantage might suggest the idea of attempting to bias the public opinion, no communication of the sort is allowed. Permission could not be obtained to mention even the particular age at which the author wrote these pieces. It was in vain the editor's partiality for them induced him to express something more than hope, that their merits with the public might rest little on that circumstance. For he has ever been persuaded, that the success of the most admired productions of the *ingenium præcox*, at least in our own language, has been much more owing to their intrinsic worth, than to the period of life at which

they

ADVERTISEMENT.

they were written. His principal motive, there-
fore, could he have imparted the particular laſt
alluded to, had been only to contribute one fact
more towards the ſcience of human nature. The
author's delicacy, however, was not to be over-
come, and to that muſt be attributed the air of
myſtery, which, it is feared, may diſcover itſelf
in introducing this publication to the world.

Whatever merit the plan of the following
work may be thought to want in ſome reſpects,
it is at leaſt preſumed to be new ; and perhaps a
better could not have been found for the diſplay
of a picturesque imagination. It was the deſign
of the writer to exhibit ſtriking objects both of
nature and art, together with ſome ſketches of
human life and manners, through a more origi-
nal medium than thoſe uſually adopted in the
walk of novel-writing and romance. How far
the attempt has ſucceeded is now left to the can-
did deciſion of the public.

<div align="right">

THE EDITOR.

</div>

Aldrovandus Magnus.

THIS illuftrious artift was one of the firft who brought the art of painting in oil to a degree of perfection. It is well known, that Hubert and John Van-eyck in a manner difcovered this admirable fecret, the finding of which occafioned almoft as much trouble as the refearches after the philofopher's ftone; but though the Van-eycks fucceeded to the admiration of all Europe, ftill the moft experienced colourifts unanimoufly allow Aldrovandus to have exceeded them in every refpect. His varnifh (compofed chiefly of nut-oil) gave a fuperior glow to his paintings,

B rendered

rendered the tints more mellow, and the nice ſtrokes of his pencil far more diſcernable than thoſe of the Van-eycks: this circumſtance alone is ſufficient to give the preference to our artiſt, had not his knowledge of the demi-tints raiſed him above all his predeceſſors. Bruges claims the honour of his birth, which happened on St. Simon's day, 1473. His parents, wealthy merchants trading to the Levant, intended to ſend him into thoſe countries, that he might acquire the language and be ſerviceable in their commerce. Every thing was agreed upon, and the day fixed for his departure. Fortunately for the arts, Jean Hemmeline, a diſciple of the Van-eycks, chanced to pay a viſit to the old Aldrovandus, his beloved friend, on the eve of his ſon's departure. Obſerving a

number

number of loofe papers covered with
fketches of animals and figures, fcattered
about the apartment, Hemmeline was
tempted to take up fome of them, and
fitting down began to examine them
with attention. He had not long con-
templated them, before he broke out
into exclamations of furprize, and en-
quired haftily for their author. The
father, who was writing at his defk by
the fire fide, paid little attention to his
friend's enthufiafm, and it was not till
Hemmeline had pulled him three times
by the fleeve that he cared to give any
anfwer. Being of a very phlegmatic
difpofition, he replied coolly, " that they
were his fon's fcratches, and that he be-
lieved he would ruin him in paper were
he to live much longer in fuch an idle
way." " Truly," faid his mother, who

B 2 was

was knitting in a great chair oppofite to his father, and who was refolved to put in her word, "our child is very innocently employed, and although he doth marr a little paper, or fo, there is no need of fnubbing him as you always do." "Woman," anfwered old Aldrovandus, "ceafe thy garrulity, our fon will be fhipped off to-morrow, fo there needs no farther words." Upon this the mother burft into tears, and, as fhe was always averfe to her fon's voyage, took this opportunity to give vent to her forrow, and with a piteous voice cried out, "You will, then, barbarous man! Father without bowels! you will, then, expofe our firft born to dwell amongft a parcel of brutal circumcifed Moors and infidels. You will, then, have him go over fea and be fhipwrecked without

<div align="right">chriftian</div>

chriſtian burial. O Lord! O Lord!
why cannot folks live every one under
his own figtree, without roving and wan-
dering through perils and dangers, that
make my blood run cold to think of.
And all this for the lucre of gain! Are
we not bleſſed with a competence at
home, without looking for ſuperfluities
abroad? Yes, my precious baby, you
ſhall not be torn from me. Here, take
my ruby croſs, my gold bodkins, and all
my parafernalia, leave me but Anthony
my ſon . . . Anthony, my ſon,
O!"—The poor lady pronounced theſe
laſt words with ſuch vehemence, that,
her ſpirits failing her, ſhe fell into a
ſwoon; and whilſt proper aſſiſtance was
called for, Hemmeline, touched with her
ſituation (for he was full of ſenſibility)
drew his chair near old Aldrovandus,
and

and held the following difcourfe: " You know, my dear friend, that Providence has been bountiful unto me, and that under its protection my talents have procured me an affluent fortune, to which I have no heir; for to fay truth, I have had no time to beget children, and matrimony I have always regarded as a gilded pill, fair to the eye and bitter to the palate; therefore I have been feveral times on the very point of making you a propofition, which perhaps may not be difagreeable." There was a folemnity in this harangue very fuitable to the genius of Aldrovandus ; the mention of affluence too and fortune tickled his ears, and the propofition not yet explained rouzed his attention. So conveying his pen into his wig, and twirling his thumbs round each other, the merchant turned a very

placid

placid countenance towards Hemmeline, who continued : " In good truth, I have fixed upon an heir; I have caſt on Anthony the eyes of adoption, and if you will but conſent, I will defray the expences you have incurred in equipping him for the voyage, then I will take him home, nouriſh him with parental tenderneſs, and next I will teach him the principles of my art; for his capacity is capacious, and if the bloſſoms of his genius are duly cultivated, they will produce ſuch fruit as will aſtoniſh the world. After my death he ſhall inherit all my poſſeſſions. Go then unto his mother, and comfort her, for ſhe is grievouſly afflicted." That I may not detain my readers with unneceſſary details, I will briefly acquaint them, that Anthony Aldrovandus was, after ſome deliberation,

tion, placed under the care of Hemme-
line, and the project of his voyage aban-
doned. Thofe who, after having been
reftrained in their warmeft inclinations,
find themfelves on a fudden free, may
conceive the joy of young Aldrovandus,
when he found himfelf at liberty to pur-
fue his beloved ftudies. He now applied
himfelf with fuch intenfenefs, that the
kind Hemmeline was obliged to check
an ardour, which might have proved
prejudicial to his health ; but nothing
could hinder our young artift from giv-
ing four hours in a day to chemiftry, his
favourite fcience. Hemmeline was very
affiduous in the laboratory, and had fome
part in the difcovery of many admirable
compofitions, which contributed to the
perfection of Aldrovandus's colours, ever
famous for their fplendor and durability.

The

The judicious Hemmeline, marking the progrefs of his difciple, thought him fufficiently grounded in his art to give his paintings to the public, and purpofely to make his talents known quitted the village of Dammé, which had been their refidence for eight years, and travelled to Ghent, where they arrived the 6th of Sept. 1492. Hemmeline immediately hired a houfe and furnifhed it with his own and Aldrovandus's paintings, which foon attracted the admiration of the curious, who flocked in crouds to behold them. Adam Spindlemans, a rich burgher of Ghent, purchafed five of the moft capital performances, which he fent as prefents to the Dukes of Parma and Placentia, princes who delighted in the encouragement of arts, and whofe cabinets began to be filled with the choiceft

productions of the pencil. Such a genius as Aldrovandus could not long remain in obscurity. George Podebrac, Duke of Bohemia, formerly the patron of Hemmeline, desired him to send his disciple to his court, at the same time promising the most ample encouragement. An offer like this was not to be rejected, especially as Hemmeline was under such obligations to the Bohemian monarch that he could hardly have refused it with decency. Besides he had other reasons, of no less consequence to his disciple's advancement. Aldrovandus was not insensible to the charms of the fair sex, and Ann Spindlemans, whose beauty and coyness had been fatal to many lovers, held him in her chains. In vain he presented her with eastern curiosities, which his mother had privately procured him.

In

In vain he laid a pair of filk ftockings
at her feet, at that period a valuable
rarity. Not all his affiduity could pro-
cure him the leaft favour, fo far was he
from hoping ever to garter his prefent
above the knee. It is incredible what
elegant clofet pictures he lavifhed upon
this haughty beauty. It was for her he
finifhed fo exquifitely the adventure of
Salmacis and Hermaphroditus, a fable
the very reverfe of his own unhappy
fituation. It was at her defire he im-
pioufly changed the facred ftory of Bell
and the Dragon, began for the Benedic-
tines, into the garden of the Hefperides,
guarded by a more fagacious monfter.
This *trait* fcandalized his mafter, whofe
chaftity had taken the alarm at feveral
other of his proceedings, and, under
pretence of vifiting his parents, he found

means

means to fnatch him from the allure-
ments of Ann Spindlemans ; nor was it
till after he had left Ghent ten leagues
behind, that he perceived the deceit.
Such are the reveries into which love-
lorn paffion plunges his votaries !———
Hemmeline, who accompanied his difci-
ple, tried by fage difcourfes to fet his
conduct in its proper light, and told him
with his accuftomed gravity, that what
was right could not be wrong, and *vice
verfâ*. He added, " that youth was the
feafon of folly, and that paffion was like
an unbridled horfe, a torrent without a
dike, or a candle with a thief in it, and
ended by comparing Ann Spindlemans
herfelf to a vinegar-bottle, who would
deluge the fallad of matrimony with
much more vinegar than oil." He con-
tinued for two long hours in this figura-
tive

tive ftyle, when obferving his difciple's
eyes nearly clofed, he gave another fillip
to his imagination, and attempted to ex-
cite his attention by more fplendid ideas.
Now he reprefented to him what golden
advantages would fpring from his refi-
dence at Prague, what honours, what
emoluments; and next he brought to
view Duke Podebrac, with great folem-
nity appointing him his painter, and
holding forth chains and medals deco-
rated with coftly gems, as the reward of
his labours. Thefe chains and medals
the fagacious painter took great care
to wave frequently before the eye of
his fancy, and this leffened, in fome
meafure, the acutenefs of his forrow.
Thefe flattering dreams ferved to alle-
viate his grief during the journey, and
before he arrived at Prague had almoft
effaced

effaced Ann Spindlemans from his me-
mory. How inconſtant is youth, how
apt to change, how fond of roving!
But let us return to our artiſts, who met
with the moſt honourable reception from
the Duke. He immediately gave them
an apartment in his palace, appointed
them a magnificent table, and officers to
attend them.

Aldrovandus, delighted with the ge-
nerous treatment he had received, re-
ſumed his employments with double
alacrity, and began an altar-piece for
the cathedral, in which he may be ſaid
to have ſurpaſſed himſelf. The ſubject,
Moſes and the burning buſh, was com-
poſed in the moſt maſterly manner, and
the flames repreſented with ſuch truth
and vivacity, that the young Princeſs
Ferdi-

Ferdinanda Joanna Maria being brought
by the Duchefs, for a little recreation, to
fee him work, cried out, " La ! Mamma,
I won't touch that bramble bufh for fear
it fhould burn my fingers!" This cir-
cumftance, which I am well aware fome
readers will deem trifling, gained our
painter great reputation amongft all the
courtiers, and not a little applaufe to her
Serene Highnefs, for her aftonifhing dif-
cernment and fagacity. All the nurfes
and fome of the ladies in waiting de-
clared, fhe was too clever to live long,
and they were not miftaken, for this ad-
mirable Princefs departed this life Jan.
23d, 1493, and it was unanimoufly ob-
ferved, that had fhe lived, fhe would
have been indubitably the jewel of Bohe-
mia. This may feem a digreffion ; but
as it was her Serene Highnefs who firft

<div align="right">gave</div>

gave her fpotlefs opinion of our artift's
merit, I could not difpenfe with men-
tioning thefe few words in relation to
her, and confecrating a tear to her me-
mory. Aldrovandus was fenfibly af-
flicted at her lofs, and painted her apo-
theofis with wonderful intelligence. He
reprefented the heavens wide open,
and the Bleffed Virgin in a rich robe of
ultramarine, feated, according to cuftom,
on the back of the old ferpent, whofe
fcales were horribly natural. Mercury,
poetically habited, was placed judicioufly
in the off-fkip, with an out-ftretched
arm, receiving the royal infant from the
city of Prague. She was draped in a
faffron ftole, which feemed to float fo na-
turally in the air, that a fpectator might
have fworn the wind blew it into all its
beautiful folds. Above were gods and
goddeffes,

goddeffes, faints and angels. Below were forefts and gilded fpires, nymphs, fauns, dryads and hamadryads, all claffically adorned with emblems and fymbols. This mafter-piece gained him the efteem of Podebrac and the whole court, to which was added a rich chain with the Duke's picture, and a purfe containing 1000 rixdollars. Encouraged by this liberality, Aldrovandus exerted himfelf more and more. It is from this time we may date fome of his moft capital productions. The tower of Babel, in which he expreffed the confufion of languages, Lot's wife, the Duchefs of Bohemia, and two highly finifhed landfcapes, fince loft in the confufion of war, were all difperfed among the Bohemian nobles, who vied with each other in loading him with prefents. His genius was

D now

now in its full vigour, his touch fpirited,
his colours harmonious, and his drawing
correct. Italy envied the Bohemian
court the poffeffion of fuch an artift, and
feveral of her Princes tried all poffible
means to engage him to vifit them ; but
notwithftanding the great defire he had
to behold the lovely profpects of Italy,
the magnificence of Rome, and the re-
mains of ancient grandeur fo interefting
to a picturefque eye, he refufed every
offer, and refolved never to quit a mo-
narch, from whom he had experienced
fuch generofity. Podebrac, charmed
with thefe fentiments, decorated him
with the order of the Ram, and gave him
in marriage Joan Jablinoufki, a young
lady to whom nature and fortune had
been lavifh of their favours. Their
nuptials were celebrated by torch light

in

in one of the royal gardens, and their
Majesties and the whole court graced
the ceremony with their prefence; but
this entertainment was unfortunately
interrupted by the sudden death of
Hemmeline, who had long been troubled
with a *boulomee*, or voracious appetite,
which occafioned him to devour what-
ever was fet before him with a frightful
precipitation. He met his fate in a huge
pike, which he foon reduced to a mere
fkeleton, and foon after feeling a death-
like cold at his ftomach, called feebly to
Aldrovandus, fqueezed his hand and ex-
pired. The bridegroom was dreadfully
difconcerted by this event, for he fin-
cerely efteemed his mafter, notwithftand-
ing the reproofs he had often received
from him; and indeed he had every
reafon to refpect his memory, as all the

wealth

wealth of Hemmeline now became his own.

Aldrovandus was now arrived at the fummit of profperity : univerfally efteemed and admired, careffed by a puiffant Prince, folaced by the blandifh- ments of a lovely fpoufe, this happy painter had not a wifh unfatisfied. He now began to enjoy his opulence in a palace he had built, and there divided his time between the delights of his art and the pleafures of fociety. Difciples flocked from very remote parts to feek his inftructions ; but he difmiffed them all with handfome prefents, two only ex- cepted, whofe conduct particularly won his efteem. The two elect were An- drew Guelph and Og of Bafan, fince fo famous in the annals of painting. The affiduity

affiduity of thefe young men was incre-
dible, and their talents aftonifhed Aldro-
vandus, who ufed always to be faying,
" If Og had lived before the Deluge, he
would certainly have obtained permiffion
from Noah to have been of the party in the
ark." Andrew Guelph he allowed to pof-
fefs great merit, furprizing fire of genius,
and an imagination tempered by fcience,
and confequently fuper-excellent. In
converfing with his chofen friends, and in-
ftructing his difciples, Aldrovandus paff-
ed many happy years, diverfified by the
birth of four children, to whom Ferdi-
nand gave letters of nobility. At length
fortune, tired with lavifhing on him her
gifts, clouded the evening of his life by
an unforefeen misfortune. As he and
his difciples worked night and day at a
fuite of paintings which was to contain

the

the whole hiſtory of the Goths and Van-
dals, canvas began to grow exceedingly
rare, and Ferdinand, touched with the
lamentations of his favourite, ſummoned
a ſolemn council, at which he ordered
him to aſſiſt, with Andrew Guelph and
Og of Baſan bearing the ſketches of part
of the great hiſtorical work. The coun-
cil aſſembled ; Podebrac aſcended the
throne ; the trumpets ſounded ; the
painters arrived, and the paintings were
expoſed to the admiration of this auguſt
aſſembly, who conferred on Aldrovan-
dus the title of Magnus, *nem. con.* Af-
terwards they proceeded to buſineſs, and
voted a ſupply of canvas. Several of
the nobles diſtinguiſhed themſelves by
very elegant harangues, and his Highneſs
iſſued forth a proclamation, whereby he
declared it treaſon for any of his liege
 ſubjects

subjects to conceal, purloin, or alienate any roll, bundle, or fardel of canvas within his dominions, thereby impeding the collection which the aforesaid Aldrovandus Magnus, Knight of the most noble order of the Ram, was empowered to make. Now waggons and sledges arrived from every quarter, bringing the tributary canvas to Aldrovandus's palace. He, transported with gratitude, and fired by that enthusiasm to which we owe so many capital works, resolved to outdo his former outdoings, on the subject of Prince Drahomire, who in the year 921 was swallowed up by an earthquake in that spot where now stands the palace of Radzen. Animated by this glorious subject, he cried aloud for canvas, but instead of canvas, his disciples, with singed beards, brought the news of the conflagration

flagration of his warehouse, in which
every thread of it was confumed. What
a difappointment to collected genius! A
paroxyfm of grief enfued; and calling
out continually "Drahomire! Canvas!
and St. Luke!" Aldrovandus Magnus
expired. There was hardly a dry eye in
Prague. The Duke groaned; the cour-
tiers wept; his difciples painted his cata-
ftrophe; the people put on black; the
univerfity compofed epitaphs, and Pro-
feffor Clod Lumpewitz exceeded them
all. His performance happily efcaped
the wreck of time, and I have the plea-
fure of fetting it before my readers, with
a verfion, fuppofed to be made by the in-
genious Mafter John Ogilby.

Pictor Alexandri titulum gerit Aldrovandus;
Pictor erat magnus; magnus erat Macedo.
Mortis erat fimilis (fic fertur) caufa duobus:
 Huic regna, autem illi cannaba deficiunt.

<div align="right">Magnus,</div>

Magnus, the title of old Alexander,
Was alſo that of Painter Aldrovand' here :
The one for want of * worlds to conquer cried,
T' other for lack of canvas nobly died.

* It is remarkable that the learned Profeſſor Clod
Lumpewitz ever maintained that this renowned Conque-
ror was cruelly aſperſed, by thoſe who have killed him
by drinking; and inſtead of merely crying for more
worlds to conquer, he inſiſted that he died ſolely on that
account. The critical reader will obſerve, that the ad-
mirable Ogilby, in conformity with the general opinion,
has taken a ſmall liberty with his author.

E

Andrew Guelph,

AND

Og of Bafan,

DISCIPLES of ALDROVANDUS MAGNUS.

THE obfcure village of Bafan, fitu-
ated on the wilds of Pomerania,
gave birth to Andrew Guelph and to
Og, from thence denominated, of Bafan.
Andrew's parents were reputable far-
mers, who tilled their own lands, and had
the comfort of feeing their numerous
herds grazing in their own paftures.
Without the delicacies of life, they en-
joyed every neceffary, and being ignorant
of a higher ftation were amply contented

<center>E 2</center>

<div align="right">with</div>

with their own. Geoffry Simons, or Sikimonds, the brother of Andrew's mother, was esteemed the father of Og, tho' there are who assert he was of far more illustrious extraction; as Prince Henry Suckingbottle and Felt Marshal Swappingback had passed through his native village some nine months before his birth, and had honoured his mother with particular marks of condescension and affability. But whether they really were his earthly fathers I will not pretend to determine; certain it is that they stood by proxy as his godfathers, Feb. 3, 1519, in the parish church of St. Sigismund, and by their desire he was baptized by the name of Og, common to their illustrious ancestors.

The relationship between Og and Andrew

drew afforded them frequent opportuni-
ties of being together, and the fimilarity
of difpofition united them by much
ftronger ties than thofe of blood. Their
employments frequently called them into
the fields, and it was in mutually delight-
ing to obferve nature, that they firft im-
bibed the defire of imitating her produc_
tions. Seldom did the fun fet before they
had engraved on the rocks the refemblance
of fome of the fhrubs that grew from the
fiffures, or the likenefs of feveral of the
goats that came to drink at the fpring
beneath. The defire of excelling each
other produced many furprizing efforts
of genius, and it happened after they
had amufed themfelves almoft five years
in covering the neighbouring rocks with
their fculptures, that Og's mother unfor-
tunately loft a fheep, on which fhe had
placed

placed her affections. Searching for her
loft favourite she climbed the rocks,
to which her son and his friend were
accuftomed to refort. The firft ob-
ject that ftruck her eyes was the por-
trait of the animal she was looking for,
fketched out upon the ftone. When
she returned home she could not help
relating what she had feen to a Jew, who
frequented her houfe, and who had been
educated a painter. The Jew offered to
cultivate the talents of Og, and Andrew
ardently begged to receive his inftruc-
tions together with his friend. Their
joint requeft granted, both learnt with
the greateft avidity; but at the end
of two years finding they excelled their
mafter, they entreated their parents for
permiffion to travel to Prague, where
they might improve under fo great a
painter

painter as the famous Aldrovandus.—
The parents confented, and the young
men fet out in the depth of winter for
Bohemia, and arriving at Prague were
received in the manner I have related by
Aldrovandus. After his death they fold
a cabinet of their own and their mafter's
paintings for a confiderable fum, and then
fet out together for Tyrol, which they
had a great defire to fee, as the wildnefs
of the landfcapes and the romantic gran-
deur of the mountains, promifed them
excellent fubjects for the pencil. A
tent, two mules, and an Hungarian fer-
vant (whofe portrait Andrew took great
delight in drawing) was all the baggage
and fuite with which they were encum-
bered. During the fummer months they
roved from one part of this beautiful
country to another; now pitching their

tent

tent in a green valley by a waterfal, now gaining the highlands and living amongſt the mountaineers; whoſe queer countenances and uncouth dreſſes furniſhed them with admirable ſtudies. The rude ſcenery of theſe mountains ſuited the melancholy of Og's imagination, which delighted in ſolitude and gloom. He ſequeſtered himſelf from his companion, hid himſelf in the foreſts of pines, and deſcended into caverns where no one had ever penetrated. Whilſt Og was delivering himſelf up to his genius in theſe wilderneſſes, Andrew, whoſe imagination was leſs fervid, contented himſelf with the humbler proſpects of the valleys. He took pleaſure in the converſation of the peaſants, and on a moonlight evening would take his guitar, and accompanying it with his voice, enliven the

<div align="right">ſimple</div>

aſſembled peaſants before their ſimple
habitations. There are ſaid to have been
two pictures in the Duſſeldorp collection
by his hand, in which he has placed himſelf
at the door of a hovel, ſurrounded with
a groupe of children ; their eyes beam-
ing with mirth, and looking at a young
man, who is capering under the ſhade of
a beech tree, through whoſe leaves qui-
vers the light of the moon. On a bank
ſit ſeveral young peaſants, whiſpering to
one another ; their features ſcarce diſ-
cernible; their limbs finely proportioned
and their attitudes ſpirited. Behind lies
a wide extended country, concealed by a
beautiful haze ; the diſtribution of light
and ſhade are very maſterly, the tints ſoft
and mellow, and the aërial perſpective
admirable. Many connoiſſeurs give this
moon-light the preference to any they
have ever ſeen. Andrew, during his ſtay

in thefe vallies, applied himfelf to bo-
tany, and introduced a vaft variety of
plants in the foreground of his land-
fcapes, which he never failed of finifh-
ing with the moft fcrupulous exactnefs.
Monfieur Van Slingelandt, of the Hague,
is in poffeffion of one of thefe views from
Tyrol, where the artift has faithfully
imitated the cataract of Brawling-bub-
ble, fhaded by a variety of trees, and
eftimable on account of the innumerable
aquatic plants he has placed on the mar-
gin of the torrent. They are coloured
with truth, and touched with fuch light-
nefs and facility as is truly furprizing.
A bridge formed of the ftumps of fir-
trees, and a rainbow produced by the
fpray of the water, has the fineft effect
imaginable. The fky is warm and glow-
ing : feveral golden clouds envelope the
fetting fun, whofe beams pierce through
the

the thickets, and partially enlighten the off-fkip; but a want of keeping in the back ground, where the painter has brought fome very diftant peaks too near the eye, offends the critical fpectator. Andrew waited near half the fummer for his companion, and had nearly given him up for loft, when one morning, as he was ftraying by the banks of a rivulet, he faw a ftrange figure defcending a precipice with wonderful alertnefs. Judge of his furprize, when fhortly after he recollected the well known features of Og of Baſan, moft reverently mantled in a long beard. Andrew defired his friend to quit this favage ftate, and then begged to know for what purpofe he had undertaken fo wild an expedition. For the love of my art, replied Og with fome warmth; I have beheld nature in her

F 2 fanc-

fanctuary, I have contemplated the tem-
peft gathering at my feet, and venting
its fury on thefe contemptible habita-
tions. You have idly remained amongft
thefe herdfmen, thefe unfeeling clowns,
whilft I have difcovered the fource of
rivers and the favage animals that inha-
bit them. Here, take my papers and
obferve what fcenes I have imitated.
Andrew took the drawings with impa-
tience and devoured them with his eyes.
"What rocks! exclaimed the tranfported
painter ; what energy in the ftrokes of
this pencil ! Indeed, continued he, turn-
ing to his friend, who was reciting fome
lines he had compofed amongft the
mountains, you have acquired a new
manner. Our mafter Aldrovandus ne-
ver equalled the magnificent forefts you
have reprefented. Then what harmony
in

in thefe tints ! What a gradation of fha-
dow ! But this fketch exceeds them all.
What are thefe vifionary beings you have
introduced? Is not that auguft figure,
bending over the torrent, Aldrovandus?"
He continued a long while to interrogate
his friend, and then began a very ferious
converfation, in the courfe of which they
agreed to quit Tyrol and pafs into Italy,
to make their talents known, and to cul-
tivate the fociety of thofe illuftrious paint-
ers, whofe fame had reached the very
extremities of Europe. This refolution
taken was not long in executing, and
paffing over the mountains they difco-
vered the plains of Italy, for the firft
time, Sept. 1540.

Every city prefented to them a multi-
plicity of objects with which they were
 unac-

unacquainted. Venice ftruck them with
furprize, and being long accuftomed to
fcenes of nature, they were aftonifhed, ra-
ther than delighted, with thofe of art. It
was in this city, at this period the refort
of foreigners from every part of the world,
they became acquainted with Soorcrout
and Sucrewaffer of Vienna, painters of
whom we fhall make honourable mention
in the fubfequent part of our work. Thefe
young men, who had already acquired a
confiderable reputation by their fingular
ftyle of painting, totally different from
the manner of Aldrovandus and his difci-
ples, attempted to depreciate, by a mean-
nefs too remarkable in feveral great art-
ifts, the pictures, and ftudies which
Andrew and Og of Bafan had brought
from the rocks of Tyrol. They deem-
ed them prepofterous and unmeaning,
<div align="right">found</div>

found great fault with the varnifh, pecu-
liar to Aldrovandus, condemned oils in
general, and ftrenuoufly recommended
white of egg. Not contented with thefe
criticifms, they openly attacked the me-
mory of Aldrovandus, treated him as a
vile plagiary, who copied nature inftead
of the antique models, which alone they
regarded as the ftandards of perfection;
befides that, he had never been at
Rome, was ignorant of the divine Ra-
phaello, and, to crown all, was born in
Flanders. Andrew Guelph, confcious
of the ridiculous malignity of thefe af-
fertions, prudently left the public to de-
cide, whether his paintings ought to be
condemned without trial; but Og of
Bafan, with his ufual violence of temper,
infifted upon an affembly of the *cono-*
fcenti being fummoned, and claimed the
pri-

privilege of confronting his works with thofe of Sucrewaffer and Soorcrout of Vienna. Accordingly the *conofcenti* were convoked, a day appointed, and a ca-fino chofen for the rendezvous of the affembly.

Andrew Guelph prepared his moon-light for the occafion, and Og of Bafan a wildernefs, in which he introduced the temptation of our Saviour. His rivals brought each of them pieces, which they efteemed capital. Signor Andrea Boccadolce, prefident of the fociety, having taken the chair, and the pictures being placed in a row before him, filence was proclaimed, and Og of Bafan commanded to advance and vindi-cate the ufe his mafter, Aldrovandus

Magnus,

Magnus, had made of nut oil, preferably
to white of egg, defended by Sucrewaſſer
and Soorcrout.

Og of Baſan obeyed, and with a mo-
deſt aſſurance ſtepped into the middle of
the aſſembly, hemmed three times, caſt
a terrible eye upon his antagoniſts, bowed
to the preſident, and began in the follow-
ing terms. " Had I even a third part
of my maſter's merit, I ſhould not with-
out fear hazard my opinion before ſo
reſpectable an aſſembly, diſtinguiſhed by
their profeſſion, and ſtill more by that
rare knowledge, and that taſte in it, which
they have diſplayed on ſo many preced-
ing occaſions. Imagine not, illuſtrious
Signors! 1 am ignorant of my rivals
merit. Their performances have doubt-
leſs met with no more than deſerved ap-

G plauſe;

plaufe; and had the hens of your facred
republic ceafed depofiting their eggs, you
would then have unanimoufly allowed
the beauty evident in every ftroke; for
they might have been vifible; but I muft
confefs the fplendor of their incompara-
ble varnifh has bereft me of eyes to exa-
mine what, I doubt not, merits the moft
exact attention." Here Soorcrout bit
his lip, and Sucrewaffer fcratched his
elbow: Signor Boccadolce whiftled gen-
tly, and the *conofcenti* looked at one an-
other, as if they had never thought of
this before. Og proceeded. " Aldro-
vandus, whom the Duke of Bohemia
regretted to his laft moments; Aldro-
vandus, the pupil of Hemmeline; Al-
drovandus, who obtained the title of
Magnus, anointed his pictures with nut-
oil: fhew me a more illuftrious example
and

and I will follow it. Ah! if we could
recall this great man from the tomb, in
which I faw him interred, how ably
would he defend the caufe of nut-oil.
Had my feeble voice but half the unction
of his tongue, I fhould confound you
partizans of white of egg : I fhould drive
you to defpair : Ye would hide your-
felves from this affembly: Ye would
make an omelet of your eggs and bury
them in your own entrails." So faying,
the artift advanced towards his rivals,
who retreated in proportion, and, with a
full fwing of his arm, tore away the cur-
tain from his picture, and expofed his
wildernefs to view. A murmur of ap-
plaufe ran through the whole affembly,
when they beheld this prodigy of art,
where the tempter ftood confeffed in all
his wiles, and Signor Boccadolce pro-

nounced,

nounced, that no varnifh but nut-oil could fmooth a wildernefs, or give fo amiable a polifh to the devil's horn. Andrew immediately uncovering his moonlight, compleated the aftonifhment of the fpectators and the confufion of his rivals, who, refufing to difclofe their pieces, retired without delay, and left Venice the day following. Now all the *conofcenti* hurried to compliment our artifts upon the exquifite beauty of their performances; and no other varnifh but nut-oil was approved. The fketches they had brought from Tyrol were purchafed with avidity, and moft of the nobles defired them to make finifhed pictures after thefe bold defigns, and in a fhort fpace of time they found themfelves growing exceedingly rich. The Pococurante family, in particular, commanded a

whole

whole gallery of paintings, which was to immortalize the mighty deeds of their anceſtors. The intereſting converſation of Og of Baſan, his natural eloquence and addreſs, procured him acceſs to the firſt houſes in Venice, where he often converſed with ſtrangers, whoſe diſcourſe was full of the praiſes of Rome and Raphael, inſomuch that he determined to viſit that capital of the world, and leaving Andrew to finiſh the Pococurante gallery, he took the road of Bologna and haſtened to Tivoli, whoſe caſcades, cool grottos, venerable temples and refreſhing ſhades detained him during the heats, which continued two months. He ſpent his mornings in exploring the ſubterraneous apartments (many of which he was the firſt that had entered) and in copying the groteſques on the vaulted cielings,

of

of which he published two volumes in folio, elegantly illuminated. He was very fortunate in his researches after antiquities, having discovered some of the most estimable which now grace the Italian cabinets. His evenings were dedicated to music and the reading of Ariosto, then lately given to the world.

A young native of Tivoli, whose name we are ignorant of, was partly the cause of his lingering in this enchanted region. Her form was perfectly Grecian, and the contour of her face exceeded those of the antique Julia; but it was her taste which captivated the heart of our artist. Like him she delighted in woods and caverns, and was charmed, like him, with the ruins that lay scattered over her country. She would often lead him to meadows of greenswerd, where she had observed some

<div align="right">sculptured</div>

sculptured marble overgrown with flow-
ers; when the sun had cast his setting
gleams on the Sybil's temple, she would
hasten to her love and conduct him to
a grove of cypresses, and sing under their
shades till the moon dimly discovered the
waterfalls to her view. Then they would
seat themselves together on the brink of
the stream which runs foaming through
the valleys, and when an universal still-
ness prevailed, interrupted alone by the
waters and the bell of some distant mo-
nastery, she would select those stanzas in
the Orlando which expressed her passion,
and repeat them with rapture. Many are
the nights they passed together, and many
the mornings when they ascended the
cliffs, and beheld the sun rising behind
the towers of Rome. At length Og re-
collected, he was born not to spend all
 his

his days at Tivoli, and whilst his be-
loved nymph was sleeping by his side, he
arose, and without venturing to cast one
look behind, fled like a criminal towards
Rome: But let us leave him a prey to
his guilty reflections, and represent the
distraction of the unhappy maid, who
awoke never to recover her lost happi-
nefs. At first she imagined her lover in
the neighbouring thicket, and putting
aside the brambles with her tender arms,
searched every brake in vain. She lifted
up her voice, and filled all the valley with
her cries. She ran in all the wildness of
grief to the river, and her troubled ima-
gination represented the body of her
lover floating down the floods. A pea-
sant, who was trimming his vines, per-
ceived her agitation, and running towards
her, asked her the cause of her affliction.
 She

She defcribed her lover in fuch a man-
ner as to admit of no doubt, and the
peafant declared he had feen him at the
firft dawn on the way to Rome. She
ftarted: A cold tremor feized her whole
frame: She would have fallen had not
an aged pine fuftained her. She opened
once more her eyes, and cafting a laft
look on the fcenes of her former happi-
nefs, plunged headlong into the tide, and
was feen no more. Whilft this new
Olimpia* added another victim to love,
her Bireno was gracioufly received by the
Cardinal Groffocavallo, who lodged him
in his palace and prefented him to his
Holinefs, who was pleafed to command
two altar-pieces, and to name two fa-
mous miracles for their fubjects; the one
St. Dennis bearing his own head, in-

H tended

* Alluding to a ftory in the 10th canto of the Orlando
Furiofo.

tended as a prefent for the King of France; the other St. Anthony preaching to the fifhes, which was to be fent to Frederick the Simple, King of Naples. Og fucceeded wonderfully in both performances. The aftonifhment in the head at finding itfelf off its own fhoulders was exprefled to admiration, and the attitude of the bleffed St. Dennis as natural as that of any man, who ever carried fuch a burthen. In the fecond picture he placed St. Anthony on a rock projecting over the fea, almoft furrounded by fhoals of every fpecies of fifh, whofe countenances, all different, were highly expreffive of the moft profound attention and veneration. Many perfons fancied they diftinguifhed the likenefs of moft of the Conclave in thefe animals; but this is generally believed to be a falfe obferva-

tion,

tion, as the painter had no pique againſt
any of their Eminences. What, how-
ever, gave riſe to this idea, was, as I learn
from the beſt authority, ſome diſlike he
entertained againſt Cardinal Hippolito
d'Eſt, on account of his ſtupid treat-
ment of his beloved poet Arioſto. He
was even heard to repeat one day, when
this Cardinal was advancing towards
him, the following line from the Orlando:

Vi venia a bocca aperta il groſſo tonno.

After he had finiſhed the altar-pieces
above-mentioned, and preſented them to
his Holineſs, he deſired permiſſion to
ſtudy the works of Raphael, diſperſed in
the apartments of the Vatican. So rea-
ſonable a requeſt was not denied, and our
artiſt, permitted to viſit every part of this
immenſe palace, ſpent two months in
ſtraying through the vaſt ſaloons, exa-

H 2 mining

mining the antiques with a critical eye, and copying the paintings of Raphael. Charmed with the folitude of many of the coved halls in this ftupendous edifice, he frequently retired to them with a few books he had chofen from the famous library, and his own volumes of defigns. It was with difficulty he could be forced from his retirement to take the neceffary fuftenance. Thus delivered up to medi‐tation, he compofed a treatife upon his art, and a differtation upon the plurality of worlds, not publifhed till after his death. He was perfectly ferene whilft occupied in this manner; but when his treatife and differtation were ended, and his defigns after Raphael compleated, he abandoned himfelf to a melancholy, which overcaft all his happinefs. He would now walk by moonlight through the

the lonely galleries, and revolve in his
mind the inſtability of human grandeur.
The magnificence of the ancient Romans
reduced to heaps of mouldering ruins,
objects continually before his eyes, re-
minded him of the fall of empires, and
this idea was attended by a ſeries of
others ſtill more gloomy. " So many
great characters (ſaid he, as he was read-
ing Tacitus on the capital of a broken
column) paſſed away like fleeting clouds,
of which no traces remain, fill me with
the moſt intereſting reflections. Where
now are thoſe crouds, which aſſiſted at
the dedication of the capitol, that rended
the air with their acclamations at the tri-
umphs of Pompey, that feaſted at the
table of Lucullus? All are no more.
The time too muſt come, when theſe halls
will be levelled with the plain, theſe
<div align="right">arches</div>

arches fall to the ground, and that awful period may alſo arrive when the moon ſhall ceaſe to caſt her gleams over their ruins." The recollection of Tivoli now ſtole inſenſibly into his mind: He grew troubled, and reproached himſelf a thouſand times with having deſerted one who had ſacrificed all for him. Tho' he was ignorant of her ſad fate, the delicacy of her ſenſations recurred to his memory with innumerable circumſtances, which revived all his former tenderneſs, and many dreadful ſuſpicions haunted his fancy. If he ſlept, his dreams repreſented her in the well known woods wailing as in anguiſh, or on the diſtant ſhore of rapid torrents beckoning him to conſole her in vain, for the inſtant he attempted to advance, tempeſts aroſe, and whirlwinds of fire ſnatched her ſcreaming

from

from his fight. Often he imagined him-
felf reclining by her fide in meads of
flowers, under a fky of the pureft azure,
and fuddenly fhe would become ghaftly
pale, and frowning on him, drive him to
a flood that rolled its black waves be-
tween terrifying precipices, and dafhing
into its current drag him after her, and
then he would wake in horror, crying,
" I drown ! I drown !" Indeed he feems
to have been felected as an example of
divine vengeance. Alone in this great
capitol, without a friend to adminifter
confolation, or fuftain his finking fpirits,
he returned to Tivoli, fully refolved to
make every reparation to her who had
placed fuch unmerited confidence in his
perjuied breaft. But ye who have any
fenfibility, figure to yourfelves the poig-
nancy of his grief, when the firft object
 he

he beheld was a young man, the brother
of her he had loved, and who had lately
taken the monaſtic habit, ſhuddering at
his ſight, and exclaiming, " Avaunt,
wretch ! my ſiſter plunged into that tor-
rent for thee—for thee ſhe is loſt for ever—
and ſcarce three days did my mother ſur-
vive her. Thou too ſhouldſt join them, or
I would die a thouſand deaths, did not my
order forbid me to vindicate my wrongs.
'Tis to my future hopes thou oweſt thy
preſent ſafety ; but be gone, leſt I break
my vow, and ſacrifice thee to my re-
venge." Cowardice generally accom-
panies guilt : Og, terrified at the reſolute
aſpect of the young man, and appalled
by the lively ſenſe of his wrongs, retired
without making any reply, and re-
mounting his horſe, which he had led
when he aſcended the ſteeps of Tivoli,
galloped

galloped away with aſtoniſhing ſwiftneſs, without determining where to direct his route. In every paſſing wind, he fancied he heard voices upbraiding him with his crimes, and cries denouncing vengeance ſeemed to iſſue from every thicket he left behind. At length, harraſſed by continual fears, he ſtopped towards the cloſe of the evening, near the ſepulchre of Cecilia Metella, and throwing himſelf from his wearied horſe, which he left careleſsly to drink at a fountain, ſought the interior of the ſtructure. There, beneath the covert of a ſolitary pine, he folded his arms and remained till night in ſilence, the image of deſpair. The ſcreeches of noxious birds, which fre-quented the edifice, rouzed him from his trance. He ſtarted up, and quitted the ruins with terror, as if he had been per-

I ſonally

fonally guilty of the murder, and without looking for his horfe, turned his fteps towards a garden he juft diftinguifhed in the twilight. As he had taken no fuftenance the whole day, fome branches loaded with fruit, that hung over the wall, offered themfelves oppo:tunely to allay his hunger. Whilft he was gathering them the moon arofe, and difcovered faintly the defolate fcene around: There a pillar yet erect with an humble fhed beneath, whofe roof leaned on its bafe: Here a tract of uncultivated ground ftrewed with the fragments of fuperb edifices, long fince laid low: There the remains of fountains and aqueducts, whofe hollow arches ftill ecchoed the murmurs of rivulets, which forced their feeble courfe with difficulty thro' heaps of mouldering marbles, and

roots

roots of fantaſtick laurels. Rome lay
extended beyond, diverſified by its domes
and ſpires, and marked by a dim haze,
proceeding from the lights in its palaces.
Our wanderer liſtened to the confuſed
founds of muſic, of revelry and triumph,
which aroſe from the numerous habita-
tions, but it was with diſguſt. He
loathed every thing that was allied to
joy, and abhorred all that beſpoke feſti-
vity. He remained uneaſy till the uproar
ceaſed, and, when the ſurrounding re-
gions were huſhed in the moſt profound
tranquillity, began his complaints. He
was on the very point of depriving him-
ſelf of exiſtence, and walked to and fro,
agitated by all the violent emotions of
deſpair. Half the night was ſpent in
vain lamentations, and the grey twilight
was juſt beginning to be viſible, when,

<div align="center">I 2</div>

wearied

wearied with inquietude, he funk down on the ground and fell into a flumber, in which the fcene hovered before his fancy: A fictitious city was ftretched out before him, enlightened by a ficti-tious moon. The fhade of her he loved fkimmed along a colonade, which caft its fhadows on the plain, and then ftood leaning on the lonely pillar, uttered a feeble groan and glided by his fide. Her wet garments clinging round her delicate fhape, her fwollen eyes and drooping hands, announced a melancholy fate. She feemed to fay, " Why do my affec-tions ftill linger on thee beyond the tomb !—Why doth my pale bofom ftill cherifh its wonted fires !—How comes it that I do not appear riding on a fulphu-reous cloud, fhaking a torch in my hand and fcreaming out Perjury !—No ! my

gentle

gentle nature forbids me to injure thee. But mark! Quit yonder fatal city ; feek the iflands of the fouth, and may'ft thou expiate thy crime!" The form next fhed fome vifionary tears, and feemed to mingle with the mifts of the morning. Og, awakened by the fun beams, recollected his dream, and without even taking leave of the Cardinal Groffocavallo, in whofe care he had depofited a coffer containing the rewards of his pencil, heedlefsly took the road to Naples, refolving to pafs into Sicily, and end his days in that ifland.

For the fake of brevity, let us fuppofe him arrived as far as Naples, ignorant of any perfon to whom he might addrefs himfelf, without money and afhamed to own himfelf in diftrefs. This was a mortifying fituation to one who had been
accuftomed

accuſtomed to affluence and familiarized with proſperity. A kind of falſe pride prevented his making uſe of his art to extricate himſelf from theſe difficulties. " What, ſaid he, ſhall I, who have been courted by the nobles of Venice and the princes of Rome, whoſe pieces have been ſought after by the Holy Father himſelf, condeſcend to offer them to a Neapolitan rabble for a morſel of bread? But were I to preſent myſelf to the King, and implore his protection, my mean appearance, ſo different from the idea which has been formed of me, would expoſe me to the deriſion of the whole court. What ſhall I do?—To whom ſhall I apply for ſuccour? Were I to meaſure back my ſteps to Rome, that city would remind me of all my miſery, and renew all my ſorrows; and muſt I not expect

to

to be received as a man bereft of reafon,
a flave to inconfiftency?"

It happened, whilft Og was bewailing
himfelf in this manner, that a vaft con-
courfe of people, all hurrying to enter a
church, attracted his attention, and, with-
out rightly knowing what he did, he
joined the throng and followed it into a
chapel, where, to his furprize, he beheld
his picture of St. Anthony preaching to
the fifhes placed over the altar and ad-
mired with univerfal rapture. One per-
fon was charmed with the pofition of the
faint, his outftretched arm and enthu-
fiaftic countenance. Another praifed the
amiable phyfiognomy of an huge thunny,
firft and foremoft amongft the auditors.
A third impioufly wifhed fuch fine fifh
transferred to his own table, and a wag,
who

who was fquinting in a corner of the cha-
pel, would have faid a fmart thing if he
had dared. In fhort, every body ex-
preffed their admiration after their own
way, and our painter was fo affected with
thefe impartial praifes, that he burft into
tears, and made fuch an extravagant out-
cry that the prieft was ready to foufe
him for a demoniac. But no fooner did
he declare himfelf the author of that
mafter-piece which excited fuch admira-
tion, and produce fome defigns he always
carried about with him as credentials,
than the Count Zigzaggi ftepping for-
wards welcomed him to Naples, invited
him to his houfe, and affured him of the
King's protection. Though Og was fe-
cretly overjoyed at fo obliging an offer,
yet his delicacy prevented his imme-
diately accepting it, and it was not till
after

after repeated intreaties and innumerable compliments, that he could be prevailed upon to accompany Signor Zigzaggi to his palace. As the pride of genius often increafes with poverty, Zigzaggi was dreadfully perplexed how to treat his gueft with fufficient refpect; for Og, though encumbered with no great change of raiment, would not accept of any from the Count, and fhutting himfelf up in a clofet that looked towards the Bay, with his pallet and pencils, refufed to fee any perfon till he had acquainted Andrew Guelph with his condition. An exprefs was fpeedily difpatched to Venice, and, in feven weeks after, his faithful friend arrived with a fplendid fuite, and a coffer filled with 15,000 fequines. Andrew had employed his time in a different manner from Og. He had met with no damfel

<center>K</center> that

that died for love of him, and after-
wards fcared him in his dreams. He had
whined away no months in fhady retire-
ments, nor wafted his youthful hours in
fauntering through deferted galleries, or
in moralizing upon the decline of empires.
Though he had written no differtation
upon the plurality of worlds, he had
realized, by his application, the plura-
lity of fequines, with which he was far
better contented, and Og, in his prefent
circumftances, thought he had great rea-
fon. Andrew had heard of his friend's
ridiculous conduct, and lamented his
being carried away by the impetuofity
of his imagination; but he was fo happy
in being reftored to him, that he for-
got all his faults, and from this time
would never believe he had any. Og
related his adventures with fuch a mov-
ing

ing fimplicity, that his friend diffolved
into tears, and mourned the maid of Ti-
voli with unfeigned affliction. He tried
to footh Og's melancholy by recounting
what had happened to himfelf, and de-
fcribing the ingenious productions of
Schooreel, who had travelled to the Holy
Land, where he had painted the fepul-
chre of Chrift. Andrew would not al-
low his friend to depend long upon the
Count's benevolence : he bought a houfe
and gardens on the fhore oppofite to the
ifland of Ifchia, and provided himfelf
with boats, in which he ufed to fhare the
diverfion of fifhing with his friend, whofe
mind, calmed by the lovely profpects
around this agreeable folitude, fituated
in one of the fineft climates of Europe,
began to recover its long-loft ferenity. Og,
willing to leave Zigzaggi a proof of his
K 2 gratitude,

gratitude, defired Andrew's affiftance in compofing and finifhing a picture, which fhould excel all his former productions.

They chofe a fubject capable of difplaying their various talents, and fecluding themfelves from all fociety in their romantic villa, fpent a whole winter in bringing their fcheme to perfection. The piece which refulted from this application was fo tranfcendent as to merit a very particular defcription. Our painters had been reading an old Italian poem, which related the deeds of the antediluvian giants and heroes, their aftonifhing magnificence, and the wars they waged againft the cherubims that guarded the facred mount of Paradife. It fung of Noah and the infpirations he received from the Deity, by whofe command
mand

mand he had raifed the ark, and preferved himfelf and his children from univerfal deftruction. The approach of the deluge, the confternation of mankind, the horrid defpair of the giants, and the wreck of nature, were all defcribed with fuch energy as fet the imagination of Og all on fire, and totally poffeffed him with antediluvian fubjects. He laboured with his ideas, he could not reft till he had embodied them, and during the whole time which he employed in painting the capital performance I am going to defcribe, he was in a kind of rapture.

He reprefented a vaft hall in the ark, fupported by tall flender columns of a ftrange unknown architecture. Above were domes, which admitted a pale watery light, diffufing a facred gloom over the whole

whole apartment. On the foreground he placed the venerable patriarch, in extafy at the fight of an angel, defcending majeftically on a rainbow, which caft its vivid tints on the cornices of the hall, gleaming with gems. Thefe bright hues were powerfully contrafted with the fhade that prevailed in the background, where a line of portals, infcribed with myfterious characters, feemed juft emerging from the darknefs. The form of the angel feemed to hover in the air. It was lucid and tranfparent, its hair feemed like waving fun-beams, and its countenance was worthy of a minifter of the Deity. The rays which darted from the angel ftruck upon feveral altars, vafes and golden ornaments difperfed in various parts of the apartment. Thefe Andrew finifhed with his accuftomed delicacy.

delicacy. But it would be in vain to attempt giving an idea of the patriarch's countenance; fo many expreffions were united in his features. His arms were extended in the very act of veiling his face with his ample robe, which fell around him in variety of folds and partially covered the cedar floor, rendered with the greateft truth. Every perfon that was admitted to the fight of this performance, returned ftruck with aftonifhment. Sig. Zigzaggi, though by no means able to comprehend the fubject, or admire its fublimity, gloried in poffeffing fuch a treafure, and encouraged Og of Bafan to paint its companion, who ftill adhering to his antediluvian fubject, defigned another chamber in the ark, lefs awful than the former, but more pleafing. Noah and his family appeared in

a fpacious

a fpacious apartment enlightened by lamps depending from the arched roof, which was ftudded with ftars. The painter had lavifhed a variety of fplendid decorations on the arcades which fupported the edifice, under which Shem and his fpoufe were feated on beds covered with the furs of animals. Ham and Japhet were tending a number of quadrupeds, who were difcovered behind a range of lattices. Heaps of flowers and bafkets of various fruits occupied the fpace neareft the eye; where two children were fporting with peacocks and other birds, whofe plumage feemed to give way under their preffure. Noah, with his hands clafped together, was reprefented in a tranfport of gratitude, extolling that Being who guided the ark through the waters, and forbad the waves

to

to dafh it againft the peaks of the moun-
tains. The imaginary coftume was pre-
ferved with judgment, and the light
which the lamps yielded was warm,
glowing, and well thrown on the objects.
This picture was efteemed above criti-
cifm, and its fame reaching the King's
ears, Og was fent for and conducted to a
private audience by the Count Zigzaggi.
His Majefty, charmed with the painter's
eloquent converfation, took a rich dia-
mond from his finger and prefented it to
him. Zigzaggi placed the family-piece
of the ark in one of the royal apart-
ments, from whence it was foon after
tranfported to Spain, and forms at pre-
fent the principal ornament of the Efcu-
rial. Cardinal Groffocavallo, who had
heard of our artift's fuccefs at Naples,
wrote him a very obliging letter, accom-

L panied

panied by the coffer he had placed under his care, which his Eminence had augmented by a confiderable prefent. The coffer and letter were delivered to Og by a young man the Cardinal recommended to his notice. This was Benboaro Benbacaio, who had ftudied under Julio Romano, but whofe fchool he had quitted to place himfelf under the direction of Og of Bafan. Benboaro refembled him in many refpects; particularly in an imagination wild and fingular, and a tafte acquired by a particular obfervation of nature. Above all, an enthufiaftic admiration of Og's productions prepoffeffed that painter in his favour, who received him without any hefitation, and heard with pleafure his critiques on the Roman fchool. "There they forced me," faid he, "eternally to repeat the fame fubjects;

they

they obliged me to ftudy anatomy, to which fcience I had ever a difguft ; they pinioned my imagination ; in fhort, they enflaved my pencil, which is at prefent free, and fhall be dedicated to your fervice." Benboaro had not remained a year with Og before the latter declared his refolution to him of going into Sicily, where he propofed fpending the remainder of his days in the fociety of Andrew Guelph. If, faid he to his difciple, a youth like you can forego the pleafures of this gay city, can fpurn the allurements of the world and bury yourfelf in the folitudes of Mongebello, you may follow me ; if not, open my coffers, and retire loaded with half their contents. The young man protefted the world had no charms to entice him from one to whom he was eternally attached, and, throwing himfelf at his

feet, befeeched him not to leave him be-
hind. Og confented ; and the week fol-
lowing embarked with his difciple and
Andrew Guelph for the ifland, in which
he was to caft his laft look on the face
of nature. It was in the beginning of
fummer, the fea calm and reflecting the
varied fhores of the bay of Naples, when
their bark was rowed out of port. At
night they touched at the ifland of Ca-
prea, where they landed, and pitched
their tents in a little green fpot, fhaded
with wood and in the midft of rocks and
ruins. As foon as the morning ftar ap-
peared on the horizon, they quitted Ca-
prea, and taking advantage of a brifk
gale, crowded their fails and reached
Cape Policaftro before fun-fet. The face
of the country feemed fo delightfully
wooded, that they caft anchor off a pro-
montory,

montory, and landing, began to penetrate
into the forefts which covered the fhores.
Among them they found many irregular
lawns, hemmed in by thickets of laurel and
bay, with here and there a tall pine rifing
from amongft them, whofe ftems were
loaded with luxuriant woodbines. The
fun had juft funk into the ocean when they
attained thefe pleafing regions, where the
frefhnefs of the breezes, the clearnefs of the
fprings, and the odour of the plants and
flowers, which began to be diffufed in
every gale, tempted them to erect their
tents and remain there till the full of the
moon. Another circumftance which
perfuaded them to ftay was the neigh-
bourhood of a ruin, where fome very
hofpitable peafants had erected fheds to
fcreen their herds from the heats.—Thefe
good folks fupplied them with milk, bread
and

and fruit in abundance. Being rather fatigued with their voyage, the lowing of the cattle and the buzzing of night-flies, foon lulled them to fleep. Six days were fpent in feeking herbs in the woods, drawing under the fhade, and dancing with the peafants on the green. Benboaro declared he never knew happinefs till now, and being charmed with the wild beauties of fome of his ruftic partners, he would fain have perfuaded Og of Bafan to fix his abode near their cottages; but his defigns were unalterable, and on the full of the moon he ordered him to defcend the hillocks and repair to the fhore, where the veffel was ready to receive them. He obeyed, not without relu&tance, and kept his eyes fixed on the fmoak which afcended from the cottages, whofe roofs juft peeped above the

the thickets, till the moon concealed her-
felf behind a cloud. This moment of
darknefs plunged Og into a reverie; he
thought of Tivoli and fighed. Andrew
flept, and Benboara wifhed himfelf with
the cottagers. Before morning they
were off Policaftro, and the next day
coafted the fhores of Calabria, whofe
diftant mountains were tinged with a
deep azure. The vaft forefts which
reached quite from the feet of the high-
lands to the water's edge concealed the
ruins of Peftum, at that time unknown.
Towards evening it fell calm, and our
voyagers put their oars in motion till
they approached a fhady bay, where
they refted on them and enjoyed the re-
frefhing fragrance of the vegetation,
wafhed by a gentle fhower. The calm
continuing, they landed in the bay, with
 fome

some difficulty on account of the rocks, which bordered the shore. A ridge of cliffs projected into the sea, covered by dark thickets of oak. Below were several coves that received the waters and afforded convenient baths. Above were jagged pinnacles, shaded by Italian pines and trodden alone by goats, who were frisking carelessly amongst them. Whilst Og and his companions were examining this sylvan scene, they perceived a flight of birds, pursued by eagles, take refuge in a grotto which had escaped their observation. It was spacious and lofty, its sides seemed worn by the course of waters into variety of uncouth shapes, and a rill trickled along the pavement, which was strewed with dry leaves. The whole scene reminded them of Virgil's description of a bay in the first Eneid.

Hinc

Hinc atque hinc vaſtæ rupes, geminique mi-
 nantur
In cœlum ſcopuli, quorum ſub verticelatè
Æquora tuta ſilent: tum ſylvis Scenacoruſcis
Deſuper, horrentique atrum nemus imminet
 umbrâ.
Fronte ſub adverſâ ſcopulis pendentibus An-
 trum:
Intus aquæ dulces vivoque ſedilia ſaxo,
Nympharum domus.

Here they kindled a fire and ſpent the
night in converſation. At the firſt dawn
they ſet ſail for the ſtreights, and leaving
the Lipari iſlands behind, arrived within
ſight of Meſſina juſt as its magnificent
buildings and the galliots in its harbour
were illuminated by the ſetting ſun.
They enjoyed the perfume of the clover
fields which ſurround the city, and Og
ſmiled with complacency on the iſland,
where he promiſed himſelf many happy

M years

years of peaceful retirement. No fooner
were they landed than fome of the Sicilian
nobles, who had notice of their arrival,
came down to the port to receive them,
and defired they might lodge them in
their houfes. Og drew a favourable
augury from this reception, and his dif-
ciple, pleafed with the gay profpect of the
city, and flattered by the compliments
of the Sicilians, forgot his cottagers, and
began fecretly to wifh his mafter might
poftpone his project of retirement. He
could not conceal his pleafure at finding
himfelf in an illuminated palace, at a
fplendid table, covered with delicacies
and fparkling with wines, environed by
fair Sicilians warbling the foft airs of their
country. Andrew, who was of a very
focial difpofition, bleffed the art which
procured him fuch company, and Og of
Bafan

Basan thought no more, at present, of the solitudes of Mangebello. After the repast succeeded a lively ball, at which Og danced, though rather untowardly; but when he was known to be the famous painter, nobody cared to laugh. The next day his kind patrons introduced him to the principal citizens of Messina, who delighted in the fine arts: to these he presented several volumes of sketches and designs after nature. During two years which he passed at Messina, he, together with his friend and his disciple, adorned many churches and cabinets with their paintings; but tired at length with the bustle of a city life he languished after retirement.

Andrew Guelph, who had lately married a beautiful Sicilian with considerable

M 2 riches,

riches, was by no means ready to accom-
plish this defign, and pleaded the cares
of a family for his excufe. As for Ben-
boaro, he would never quit his mafter;
neither the charms of Meffina, nor its gay
inhabitants, nor the amufements of a
lively fociety, could induce him to aban-
don him, and without difcovering any re-
luctance, he followed Og into the forefts
and wilds, which fkirt the little moun-
tains and extinguifhed volcanoes around
mount Etna. They wandered together
over all the regions of this famous moun-
tain, and at laft pitched upon a fpot near
the celebrated chefnut trees, where they
built a hut and fixed their refidence.
After they had remained about two
months in this fequeftered habitation, Og
grew reftlefs and melancholy. The
parting injunction of the maid of Tivoli
rufhed

rufhed frefh into his mind, and with re-
doubled force. He had now vifited
thofe regions, which he doubted not were
meant by the iflands of the fouth, to
which fhe had commanded him to fly.
Recollecting her laft wifh, that he might
expiate his crime, he was one day over-
heard to fay, " Ah! thofe laft words,
fo foftened by her affection, were furely
not fo much a wifh as a prophecy ; and
I, who till this moment fondly thought
myfelf purfuing a calm and long retire-
ment, in this delicious climate, have been
making my progrefs hither but to finifh
my courfe. The time of expiating my
bafenefs draws near, and methinks at
this inftant I fee the pale form of her I
betrayed hovering over me, and beckon-
ing me up to the fummit of yonder vol-
cano. Yes, there muft be the fated fcene
of

of expiation. Nor ſhall it be long, gentle
ſpirit! ere I obey thy ſummons. I
ſhall willingly ſubmit to my doom, not
deſpairing it may one day render me
worthy of thy ſociety and friendſhip in
a happier world."

Nothing could exceed the aſtoniſh-
ment of Benboaro, who caught every
ſyllable of this ſtrange ſoliloquy. The
youth, concluding his maſter's ſenſes
and imagination diſturbed, neglected no
means in his power to comfort, or aſſuage
him. All his attention, however, failed
to alleviate the ſorrow which preyed upon
Og's mind, and one morning he ordered
him in a peremptory manner to leave him
in entire ſolitude. Benboaro refuſing to
comply, his maſter ruſhed into the thickeſt
of the foreſts, and was ſhortly concealed
from

from his fight. Seven days the youth fought him in vain, traverfing wilderneffes where no one had ever penetrated, and afcending precipices which the boldeft peafant was afraid to fcale, fubfifting all the while on the fruits and berries he cafually met with. The region of fnow which encircles the Crater did not deter his enquiries. With incredible labour he ftruggled over rocks of ice, feeking his mafter's veftiges in vain. By night he was directed by the mournful light of thofe eternal fires which iffue from the peak of the mountain, and by day a few ftraggling crucifixes, erected over the graves of unhappy travellers, who had perifhed in the expedition, ferved him at once as a mark and a memorial of the perils of his route. On the fourth day, after a night fpent almoft without fleep, he

he arofe, and lifting up his eyes faw be-
fore him the mouth of that tremendous
volcano, which the fuperftition of the
times led him to believe the entrance of
Hell. The folitude in which he found
himfelf, the fullen murmur of the vol-
cano, and all the horrors of the fcene
worked fo ftrongly on his imagination,
that he fancied he beheld ftrange fhapes
defcending and afcending the fteeps of
the fiery gulph. He even believed he
heard the fcreams of defolation and the
cries of torment iffuing from the abyfs.
Such was his terror, that he neglected to
turn his eyes on the vaft profpects below,
and haftening from the edge of the Crater,
where he had ftood petrified for fome
minutes, returned over the deferts of
fnow, fainting with his toils, and in defpair
of ever beholding his mafter more.

As

As foon as he reached the verge of the woods, he fell on the ground in a deep fleep, from which he was awakened by fome peafants, who were collecting ful-phur. Of thefe he eagerly enquired, whether they had feen a man with a long beard and armed with a fcymitar? " Yes," anfwered they, " we have feen him: The vile forcerer has blafted us with his haggard eyes. He paffed us juft beneath the cliffs, which hang over the great chefnut-tree, muttering execrations and talking to the winds. A violent tempeft enfued, which has deftroyed three of our cottages, and in the midft of the ftorm we faw the old wretch that occa-fioned it fall from the cliff, wrapped in a blue flame. The Virgin preferve us from his maledictions !" Benboaro wifh-ed to hear no more ; and quitting the

N peafants

peasants without making any reply, he
returned weeping to his hut, doubting no
longer of his master's unhappy fate.
Having provided himself with chesnuts,
he crossed the wilds between the foot of
the mountain and Messina, sleeping in
the day and travelling in the cool of the
evening. All the way he bewailed the
dangers and extravagances to which ge-
nius is exposed, and arrived pale with
grief and fatigue at Andrew's house.
His countenance told his tale before he
related it. Andrew was almost distracted
with the news, and never ceased till his
death, which happened three years after,
to lament the despair of his unhappy
friend. Benboaro, still in search of instruc-
tion, sailed to Italy, shortly after his re-
turn from the mountain, in the beginning
of the year 1547, where he greatly distin-
guished

guifhed himfelf. The family of Andrew
ftill fubfift in Sicily, and have inherited
many of his valuable paintings : his fon
had a tafte for the art, and has left be-
hind him feveral pieces difperfed in the
cabinets of the curious. For diftinc-
tion, the father is called Old Andrew
Guelph.

Sucrewaffer of Vienna.

OUR readers muſt now be preſented with ſcenes and occurrences widely differing from thoſe which laſt we placed before them. They will no longer behold an artiſt, conſumed by the fervour of his genius and bewildered by the charms of his imagination; but the moſt prudent and ſage amongſt them will admire the regular and conſiſtent conduct of Sucrewaffer, which forms a ſtriking contraſt to the eccentricity of Og.

The family of the Sucrewaffers had been long eſtabliſhed at Vienna; they
had

had kept a grocer's fhop, which de-
fcended from father to fon thro' a courfe
of many generations. The father of our
artift exercifed his hereditary bufinefs
with the fame probity as his anceftors.
His mother, the daughter of a Lombard
pawnbroker, was the beft fort of woman
in the world, and had no other fault than
loving wine and two or three men be-
fides her hufband. Young Sucrewaffer
was invefted, at the age of fix years, with
the family apron, and after having per-
formed errands for fome time, was ad-
mitted to the defk at twelve; but difco-
vering a much greater inclination for
defigning the paffengers, which were
walking to fro before the window where
he was doomed to fit, than noting the
articles of his father's commerce in his
book, he was bound apprentice to an
uncle

uncle of his mother, who painted heraldry for the Imperial Court, and his brother was promoted to the defk in his room. Sucrewaffer took great delight in his new fituation, and learnt, with fuccefs, to beftow due ftrength on a lion's paw, and give a courtly flourifh to a dragon's tail. His eagles began to be remarked for the juftnefs of their proportions and the neatnefs of their plumage; in fhort, an Italian painter, by name Infignificanti, remarked the delicacy of his pencil, and was refolved to obtain him for his fcholar. The youth, finding himfelf in a comfortable habitation with a kind uncle, who was in a thriving way, and who offered him a fhare in his bufinefs when the time of his apprenticefhip fhould expire, expreffed no great defire to place himfelf under the

tuition

tuition of Infignificanti; but as that painter had acquired a very fplendid reputation, and was efteemed exceedingly rich, his parents commanded him to accept the offer, and Sucrewaffer never difobeyed. He remained two or three years with this mafter, which he employed in faithfully copying his works; generally fmall landfcapes, with fhepherds and fhepherdeffes feeding their flocks, or piping under Arcadian fhades. Thefe pieces pleafed the world in general and fold well, which was all Infignificanti defired, and Sucrewaffer had no other ambition than that of his mafter. The greateft harmony fubfifted between them till three years were expired.

About this time the Princefs Dolgoruki, then at the Court of Vienna, felected
.Infig-

Infignificanti and his pupil to paint her
favourite lap-dog, whofe pendent ears
and beautifully curling tail feemed to
call loudly for a portrait. Infignificanti,
before he began the picture, afked his
pupil, with all the mildnefs of condefcen-
fion, Whether he did not approve his
intentions of placing the dog on a red
velvet cufhion. Sucrewaffer replied gen-
tly, that he prefumed a blue one would
produce a much finer effect. His ma-
fter, furprized to find this difference of
opinion, elevated his voice, and exclaim-
ed, "Aye, but I propofe adding a gold
fringe, which fhall difplay all the per-
fection of my art; all the feeling delicacy
of my pencil; but, hark you! I defire
you will abftain from fpoiling this part
of the picture with your grofs touch,
and never maintain again that blue will

O admit

admit of half the fplendor of red." Thefe
laft words were pronounced with fuch
energy, that Sucrewaffer laid down his
pencil, and begged leave to quit his
mafter; who foon confented, as he feared
Sucrewaffer would furpafs him in a very
fhort fpace of time. The young man
was but coolly received by his parents,
who chided him for abandoning his
mafter; but when they perceived his
performances fold as well as before this
rupture, their anger ceafed, and they per-
mitted him to travel to Venice, after
having beftowed on him their benedic-
tion with the greateft cordiality.

His route lay through fome very ro-
mantic country, which he never deigned
to regard, modeftly conjecturing he was
not yet worthy to copy nature; fo with-
out

out ftraying either to the right or to the
left, he arrived at Venice in perfect
health, and recommended himfelf firft to
the public by painting in frefco on the
walls of fome cafinos. The fubjects
were either the four Seafons or the three
Graces. Now and then a few blind Cu-
pids, and fometimes a lean Fury, by way
of variety. The colouring was gay and
tender, and the drawing correct. The faces
were pretty uniform and had all the moft
delightful fmirk imaginable; even his
Furies looked as if they were half inclined
to throw their torches into the water, and
the ferpents around their temples were as
mild as eels. Many ladies ftiled him
Pittore amabile, and many gentlemen
had their fnuff-boxes painted by his
hand. He lived happily and content-
edly till he became acquainted with

Soorcrout,

Soorcrout, who was a great admirer of Titian, and advifed him by all means to copy his performances; and as he generally followed the advice of thofe who thought it worth their while to give him any, he immediately fet about it, but did not profit fo much as he expected. It was Soorcrout who engaged him in that unlucky difpute with Og of Bafan and Andrew Guelph; a controverfy which lowered them confiderably in the eyes of the world, and forfeited them the protection of Signor Boccadolce.

After this difgrace, Soorcrout went to England, and Sucrewaffer loitered in the environs of Venice till the ftorm was blown over. He then returned, lived peaceably there many years, and died at length of a cold he caught at a party on the water.

water. His moſt ſplendid performance,
Salome, mother of the Maccabees, which
he imitated from Titian, was ſold by
Soorcrout in England.

Blunderbuffiana.

IT is with difficulty we can afcertain the place or even the country where this artift was born; but we have moft reafon to imagine it was in Dalmatia, towards the confines of Croatia. Rouzinfki Blunderbuffiana, father of him whofe adventures will be the fubject of the following pages, was captain of fome banditti, for many years the terror of Dalmatia and the neighbouring countries. This formidable band exercifed the moft unlimited depredations, and as they were very numerous, nothing but an army could oppofe them. Finding, however, fecurity in defiles amongft the moun-

tains,

tains, known but to themſelves, the Ve-
netian and Hungarian ſoldiery attempted
their extirpation in vain. Rouzinſki,
their leader, was one of the haughtieſt
of mankind; his uncommon ſtature,
matchleſs intrepidity, and wonderful
ſucceſs, had raiſed him to the deſpotic
command of theſe brave ſavages, to
whom no enterprize ſeemed impoſſible,
and who executed their projects almoſt
as ſoon as they were conceived. The
caves in which they reſided were hol-
lowed in the rocks, forming the ſummit
of a mountain in the wild province of
the Morlakes, which they had in a man-
ner ſubdued; no one daring to approach
the ſpot where they had eſtabliſhed their
habitations. The peak of this moun-
tain, ſeen from afar, was regarded by
the Dalmatians with horror. Had they
known

known what fcenes it concealed, they would have trembled indeed. The plan of this work will not admit a particular defcription of this mountain and its caves, or elfe I fhould certainly have lain before my readers fome particulars concerning the refidence of thefe banditti, which, perhaps, might have been worthy their attention; but at prefent I muft confine myfelf merely to what relates to the life of Blunderbuffiana. His father returning with a rich booty from Turky, brought with him a lady of fome diftinction, who had fallen unfortunately into his hands. He conveyed her to his cave, attempted to amufe her with the fight of thofe magazines (immenfe grottos) which contained his treafures, and by degrees falling deeply in love with her, laid them all at her feet.

<div align="center">P</div>

The

The young Turk, who had feen but little of the world, was charmed with the manly afpect of her admirer, and dazzled by his liberality, after fome time forgot the difguft his favage profeffion infpired. She at length confented to make him happy; and our hero fprung from this con‑nection, which was celebrated with tu‑multuous feftivity throughout all the fubterraneous empire. Blunderbuffiana's firft ideas, caught from the objects a‑round, cannot be fuppofed of the gen‑tleft nature. He beheld gloomy caverns hollowed in craggy rocks, which threat‑ened every inftant to fall upon his head. He heard each night dreadful relations of combats which had happened in the day, and often, when wandering about the entrance of the caves, he fpied his father and his companions ftripping the

flain,

flain, and letting down their bodies into
pits and fiffures which had never been
fathomed. Being long inured to fuch
ghaftly fights, he by degrees grew pleafed
with them, and his inclination for paint-
ing firft manifefted itfelf in the defire he
had of imitating the figures of his father's
warriors.

Rouzinfki, as foon as his fon was
able to dart a javelin or bear a
mufket, led him to the chace, and exult-
ed in the activity with which he pur-
fued the boar, and the alacrity with
which he murdered the trembling ftag.
After he had fpent a year in thefe fan-
guinary amufements, his father thought
him worthy to partake his expeditions,
and led him firft to the rencounter of a
pretty large body of Turks, who efcort-

ed fome Hungarian merchants. " Such for the future muft be your game," faid the ruthlefs robber to his fon, who performed prodigies of cruelty and valour. But let me draw a veil over fuch frightful pictures. Though the truth forbids me entirely to conceal them, humanity pleads ftrongly for the abridgment of their relation. Two fummers paffed away in continual rapines and eternal fcenes of active oppreffion. The winter was the feafon of repofe, and the young Rouzinfki employed it in recollecting the adventures of the fummer months and fixing them by his pencil. Sometimes he read a treatife upon painting, found amongft the fpoils of fome Italians, which affifted him infinitely. They much recommended the ftudy of anatomy, and he did not hefitate to fol-
low

low the advice they gave. His father's
band frequently bringing bodies to their
caves, he amufed himfelf with diffecting
and imitating the feveral parts, till he
attained fuch a perfection in mufcular
expreffion as is rarely feen in the works
of the greateft mafters. His application
was furprizing; for his curiofity to exa-
mine the ftructure of the human frame
being inflamed, he purfued the ftudy with
fuch eagernefs as thofe who are not *ama-
teurs* cannot eafily imagine. Every day
difcovered fome new artery, or tendon to
his view; every hour produced fome
mafterly defign, and though without any
perfon to guide him, he made a progrefs
which would have done credit to the
moft eminent artifts. He now began to
put his figures together in a great man-
ner, and to group them with judgment;
but

but colours were wanting, and without materials, Michael Angelo would have conceived the dome of St. Peter's in vain. He had read in his treatife of the works of Italian painters, which he languifhed to behold, and was determined, if poffible, in the enfuing fummer, to efcape from his father and fly to a country, where he might indulge his inclinations; however, for the prefent he was charmed with the opportunities of perfecting himfelf in anatomy, and that occupation diverted his intention of taking flight for fome time. In the fpring he ufed early in the morning to quit his cave, and frequently truffing a body over his fhoulders, repaired to a wood, and delighted himfelf in exploring it. Inftead of carrying with him, in his walks, a nice pocket edition of fome Elzevir claffic,

he

he never was without a leg or an arm,
which he went flicing along, and generally
accompanied his operations with a me-
lodious whiftling ; for he was of a chear-
ful difpofition, and, if he had had a dif-
ferent education, would have been an
ornament to fociety.

Summer came, and he was called
to attend his father and a felect detach-
ment of the band, on an expedition into
the Hungarian territories ; but fome re-
gular troops being aware of their inten-
tions, lay in ambufh for their coming,
fallied upon them, and left the old Rou-
zinfki, with thirty of his comrades, dead
upon the field. Blunderbuffiana efcap-
ed, and made the beft of his way thro'
forefts deemed impenetrable, and moun-
tains, where he fubfifted on wild fruit
and

and the milk of goats. When he reached the borders of cultivation, his favage mien and the barbarous roll of his eyes, frighted every villager that beheld him; and fo ftrange was his appearance, that fome faid he could be nothing but the Antichrift, and others believed him to be the Wandering Jew. After having experienced innumerable hardfhips, which none but thofe accuftomed from their infancy to fatigues could have fuftained, he arrived at Friuli; where he was employed in cutting wood, by a Venetian furgeon, who had retired there to enjoy an eftate which had been lately bequeathed him. One day, after he had worked very hard, he feized a cat that was frifking about near him, and, by way of recreation, diffected the animal with fuch fkill, that his mafter,

who

who happened to pafs by, was quite fur-
prized, and mentioned this circumftance
to feveral of. his friends at dinner, a-
mongft whom the famous Jofeph Porta
chanced to be prefent. This painter,
who was a great admirer of anatomy,
wifhed to fee the young proficient, and
being ftruck with his uncouth figure,
began to fketch out his portrait on fome
tablets he carried about him. Blunder-
buffiana was in raptures during the per-
formance, and begging earneftly to exa-
mine it more narrowly, fnatched the
pencil from Porta's hand, and in a few
ftrokes corrected fome faults in the ana-
tomy with fuch boldnefs and veracity,
as threw the painter into amazement.
Happening to want a fervant at this
time, Porta defired his friend to permit
Blunderbuffiana's returning with him to

Q Venice;

Venice; a requeſt he granted without delay, and the young man joyfully accompanied him. He did not long remain with his maſter as a ſervant, being ſoon conſidered in the light of a diſciple. All poſſible advantages were procured him, and after a year's ſtudy he gave ſeveral pieces to the public, in which the *clair obſcure* was finely obſerved. The ſcenes of his former life were ſtill freſh in his memory, and his pictures almoſt always repreſented vaſt perſpective caverns red with the light of fires, around which banditti were carouſing; or elſe dark valleys between ſhaggy rocks ſtrewed with the ſpoils of murder'd travellers. His father, leaning on his ſpear, and giving orders to his warriors, was generally the principal object in theſe pieces, characteriſed by a certain horror,
which

which thofe ignorant of fuch dreadful
fcenes fancied imaginary. If he repre-
fented waters, they were dark and trou-
bled; if trees, deformed and withered.
His fkies were lowering, and his *clair
obfcure* in that ftyle the Italians call *fgraf-
fito* (a greyifh melancholy tint) which
fuited the gloominefs of his fubjects.
It might be conjectured from this choice
of fubjects, that Blunderbuffiana was a
very difmal perfonage. On the con-
trary, he was, as we hinted before, of
a focial difpofition, and much relifhed
by thofe with whom he fpent the hours
he dedicated to amufement. His plea-
fures, to be fure, were fingular, and
probably will not be ftyled fuch by
many of our readers. For example;
after a chearful repaft, which he never
failed to enliven by his fallies, he would

engage

engage some of his friends to ramble
about at midnight, and leading them
slily to some burying grounds, entice
them, by way of frolick, to steal some
of the bodies, which he bore off with
the greatest glee ; exulting more than if
he had carried alive in his arms the fair-
est ladies in the environs. This diver-
sion proved fatal to him at length ; for
he caught a violent fever in consequence
of a drinking match, which was to pre-
cede one of these delicious excursions.
The disorder, attacking his robust con-
stitution, reduced him in two days to a
very critical situation ; and, burning
with heat, he plunged into a cold bath,
out of which he was taken delirious,
and being conveyed to his bed, began
to rave in a frightful manner. Every
minute he seemed to behold the man-
gled

gled limbs of thofe he had anatomized, quivering in his apartment. " Hafte, give me my inftruments," cried he, " that I may fpoil the gambols of three curfed legs, that are juft ftalked into the room, and are going to jump upon me. Help! help! or they will kick me out of bed. There again; only fee thofe ugly heads, that do nothing but roll over me!—Hark! what a lumbering noife they make! now they glide along as fmoothly as if on a bowling-green.— Mercy defend me from thofe gogling eyes!—Open all the windows, fet wide the doors,—let thofe grim cats out that fpit fire at me and lafh me with their tails. O how their bones rattle! —— Help!—Mercy!—O!"—The third day releafed him from his torments, and his body, according to his defire, was deli-

vered,

vered, with all his anatomical defigns, to
the college of furgeons. Such was the
end of the ingenious Blunderbuffiana,
whofe fkeleton the faculty have cano-
nized, and whofe paintings, difperfed in
moft of the Venetian palaces, ftill terrify
the tender-hearted.

Water-

Waterfouchy.

WE will now change our fcenery from the rocks of Dalmatia to the levels of Holland, and inftead of failing on the canals of Venice faunter a little by thofe of Amfterdam. It was in the Kalverftraat, oppofite to the hotel of Etanfhafts, next door to the Blue Lion, that Waterfouchy, whofe delicate performances are fo eagerly fought after by the curious, firft drew his breath. The name of Waterfouchy had been known in Amfterdam fince the firft exiftence of the republic. Two wax-chandlers, and at leaft twelve other capital dealers in greafe, had rendered it famous, and

the

the head of the family can never be for-
gotten, fince he invented that admirable
difh from which his defcendents derived
their appellation. Our artift's father,
from humbly retailing farthing candles,
rofe, by a monopoly on tallow, to great
affluence, and had the honour of en-
lightening half the city. He was a
thrifty diligent man, loved a pipe of re-
flection in the evening, and invented
fave-alls; but it was for the fole ufe of
his own family. This prudent character
endeared him fo much to Mynheer Boo-
terfac, a rich vintner, his next door neigh-
bour, that he propofed to him his only
daughter in marriage, and from this al-
liance, which happily took place on the
3d of May, 1640, fprung the hero of
thefe memoirs.

The

The birth of young Waterſouchy was marked by a decent though jovial meeting of his kindred on both ſides. Much wine was drank, and ten candles aſſigned for home conſumption. Such feſtivity had not been diſplayed in the family ſince it firſt began. Nor were theſe rejoicings without other foundation, as old Waterſouchy, who had hitherto toiled and moiled from morn till eve, reſolved, at the birth of his child to leave off buſineſs, and enjoy at eaſe the fortune he had acquired. It will be needleſs to mention particularly the great care that was taken of the young Jeremy (for ſo he was baptized). Let it ſuffice to relate, that two years elapſed before he was weaned—ſo great was the tenderneſs of his parents, and ſuch their fears leſt a change of diet might endanger his con-

R ſtitution.

ftitution. It was no wonder that this
child infpired fuch affectionate fenti-
ments in his parents, fo winning was his
appearance. How could they fail to be
ftruck with the prettieft, primmeft mouth
in the world, a rofe-bud of a nofe, large
rolling eyes, and a complexion foft and
mellow like his paternal candles? This
fweet baby gave early figns of delight in
rich and pleafing objects. The return
of his parents from church in their holi-
day apparel ever attracted his attention
and excited a placid fmile, and any ftran-
ger garnifhed with lace might place him
on his knee with impunity. He feemed
to feel peculiar pleafure at feeing peo-
ple bow to each other, and learnt
fooner than any child in the ftreet to
handle his knife, to fpare his bib and
kifs his hand with addrefs. This pro-
mifing

mifing heir of the Waterfouchies had
juft entered into his fifth year, when his
father ventured for the firft time to take
him about to the Booterfacs and his other
relations. Thefe good people, enchant-
ed with the neatnefs of his perfon and the
correctnefs of his behaviour, never failed
to load him with toys, fugar plumbs, and
gingerbread; but a fpruce fet of Æfop's
Fables, minutely engraved, and fome
defigns for Bruffels point, were the pre-
fents in which he chiefly delighted.
Thefe delicate drawings drew his whole
attention, and they were not long in his
hands before he attempted to imitate
them, with a perfeverance and exactnefs,
furprizing at his years. Thefe infantine
performances were carefully framed and
glazed, and hung up in Madam Water-
fouchy's apartment, where they always

R 2 produced

produced the higheſt admiration. A-
mongſt thoſe who were principally ſtruck
with their merit was the celebrated
Francis Van Cuyck de Mierhop, a noble
artiſt from Ghent, who, during his reſi-
dence at Amſterdam, frequently conde-
ſcended to paſs his evenings at Water-
ſouchy's. Mierhop could boaſt of illuſ-
trious deſcent, to which his fortune was
by no means equal, and having a pecu-
liar genius for painting eatables, old wo-
men, and other pieces of ſtill life, applied
himſelf to the art, and made a conſidera-
ble figure. Waterſouchy's table was
quite an academy in the branches he
wiſhed to cultivate, daily exhibiting the
completeſt old women, the moſt portly
turbots, the plumpeſt ſoles, and, in a
word, the beſt conditioned fiſh imagina-
ble, of every kind. Mierhop availed
himſelf

himfelf of his friend's invitations to ftudy legs of mutton, firloins of beef, and joints of meat in general. It was for Madam Waterfouchy he painted the moft perfect fillet of veal, that ever made the mouth of man to water, and fhe prided herfelf not a little upon the original having appeared at her table.

The air of Amfterdam agreeing with Mierhop's conftitution, and Waterfouchy's table not lefs with his palate, he was quite infpired during his refidence there, and took advantage of thefe circumftances to immortalize himfelf, by an immenfe and moft inviting picture, in which he introduced a whole entertainment. No part was neglected.— The vapour fmoking over the difhes judicioufly concealed the extremities of the repaft,

repaſt, and gave the fineſt play to the imagination. This performance was placed with due ſolemnity in the But-chers-hall at Ghent, of which reſpectable corps he had been choſen protector.

Whilſt he remained at Amſterdam, young Waterſouchy was continually improving, and arrived to ſuch perfec-tion in copying point lace, that Mier-hop entreated his father to cultivate theſe talents, and to place his ſon under the patronage of Gerard Dow, ever renowned for the exquiſite finiſh of his pieces. Old Waterſouchy ſtared at the propoſal, and ſolemnly aſked his wife, to whoſe opinion he always paid a deference, whe-ther painting was a genteel profeſſion for their ſon. Mierhop, who overheard their converſation, ſmiled diſdainfully at

the

the queſtion, and Madam Waterſouchy
anſwered, that ſhe believed it was one of
your liberal arts. In few words, the
father was perſuaded, and Gerard Dow,
then reſident at Leyden, prevailed upon
to receive the ſon as a diſciple.

Our young artiſt had no ſooner ſet his
foot within his maſter's apartment, than
he found every object in harmony with
his own diſpoſitions. The colours finely
ground, and ranged in the neateſt boxes,
the pencils. ſo delicate as to be almoſt
imperceptible, the varniſh in elegant
phials, the eaſel juſt where it ought to
be, filled him with agreeable ſenſations,
and exalted ideas of his maſter's merit.
Gerard Dow on his ſide was equally
pleaſed, when he ſaw him moving about
with all due circumſpection, and noticing
his

his little prettinesses at every step. He
therefore began his pupil's initiation with
great alacrity, first teaching him cautiously
to open the cabinet door, left any particles
of dust should be dislodged and fix upon
his canvas, and advising him never to
take up his pencil without sitting mo-
tionless a few minutes, till every mote
casually floating in the air should be set-
tled. Such instructions were not thrown
away upon Watersouchy : he treasured
them up, and refined, if possible, upon
such refinements.

Whilst he was thus learning method
and arrangement, the other parts of his
education were not neglected. A neigh-
bouring schoolmaster instructed him in
the rudiments of Latin, and a barber,
who often served as a model to Gerard
Dow,

Dow, when compofing his moft fublime pieces, taught him the management of the violin. With the happieft difpofitions we need not be furprized at the progrefs he made, nor aftonifhed when we hear that Gerard Dow, after a year's ftudy, permitted him to finifh fome parts of his own choiceft productions. One of his earlieft effays was in a large and capital perfpective, in which a chriftening entertainment was difplayed in all its glory. To defcribe exactly the mafterly group of the goffips, the demurenefs of the maiden aunts, the puling infant in the arms of its nurfe, the plaits of its fwaddling-cloaths, the glofs of its ribbons, the fringe of the table-cloth, and the effect of light and fhade on a falver adorned with cuftard-cups and jelly-glaffes, would require at leaft fifty pages. In

S this

this fpace, perhaps, thofe details might be included; but to convey a due idea of that precifenefs, that air of decorum, which was fpread over the whole picture, furpaffes the power of words. The collar of a lap-dog, a velvet bracelet, and the lace round the caps of the goffips, were the parts of this *chef d'oeuvre*, which Waterfouchy had the honour of finifhing, and he acquitted himfelf with a truth and exactnefs that enraptured his mafter, and brought him to place unbounded confidence in the hair ftrokes of his pencil. By degrees he rofe to the higheft place in the efteem of that incomparable artift, who, after eight years had elapfed, fuffered him to group without afiftance. An arm chair of the richeft velvet, and a Turkey carpet, were the firft compofitions of which he claimed the exclufive honour.

honour. The exquifite drawing of thefe pieces was not lefs obfervable than the foftnefs of their tints and the abfolute nature of their colouring. Every man wifhed to fit down in the one, and every dog to repofe on the other.

Whilft Waterfouchy was making daily advances in his profeffion, his father was attacked by a lethargy, that, infenfibly gaining ground, carried him off, and left his fon in the undifturbed poffeffion of a confiderable fum of money: No fooner was he apprized of this event than he took leave of Gerard Dow, and arrived at his native city time enough to attend the funeral proceffion, and to partake of the feaft which followed it; where his becoming forrow and proper behaviour fixed him in the efteem of all

S 2 his

his relations. This good opinion he took care to maintain, never shewing more attention to one than to another, but as it were portioning out his compliments into equal shares. Having passed the usual time without frequenting the world, and having closed the account of condolence, he began to take pleasure in society, and make himself known. His scrupulous adherence to form and propriety procured him the *entré* of many considerable houses, and recommended him to the particular notice of some of the principal magistrates of Amsterdam. These grave personages thought he would do honour to their city in foreign parts, and therefore advised his going to Antwerp for the advancement of his reputation.

<div align="right">Antwerp</div>

Antwerp was at this period the centre of arts and manufactures; its public buildings were numerous and magnificent; its citizens wealthy; ſtrangers from every quarter reforted thither, for bufinefs, or for pleafure. Rubens had introduced a fondnefs for painting, and had ornamented his cabinet with the moſt valuable productions of the pencil. This example was followed, and collections began to be formed by the opulent inhabitants. Where then could a painter, bleſſed with fuch talents as Waterfouchy, expect a more favourable reception? He foon refolved to follow the advice of his refpectable friends, and having fettled his affairs and paſſed a month or two in taking leave of his acquaintance with due form, he began his journey. Many recommendatory letters

were

were given him, and particularly one to
Monſieur Baiſe-la-main, a banker of the
firſt eminence, and an encourager of the
fine arts, who united the greateſt wealth
with the moſt exemplary politeneſs. All
the way he amuſed himſelf in the track-
ſkuit with looking over the ſtock of
compliments he had treaſured up from
his youth, in order to perfect himſelf in
all the rules of that good breeding, he
purpoſed to diſplay at Antwerp. " Con-
ſider," ſaid he to himſelf, " before whom
you are to appear ; reflect that you are
now almoſt arrived at the zenith of pro-
priety. Let all your actions be regular
as the ſtrokes of your pencil, and let the
varniſh of your manners ſhine like that
of your paintings. Regulate your con-
duct by the fair example of thoſe you
will ſhortly behold, and do not the ſmall-
eſt

eft thing but as if Monfieur Baife-la-
main were before you." Full of thefe
refolutions he drew near to Antwerp.
Advancing between fpruce gardens and
trim avenues he entered the city, not
without fome prefentiment of the fame
he was to acquire within its walls. Eve-
ry manfion with high chequered roofs
and mofaic chimnies, every fountain
with elaborate dolphins and gothic pin-
nacles, found favour in his eyes. He
was pleafed with the neat perfpectives
continually prefenting themfelves, and
augured well from a regularity fo con-
fonant to his own ideas. After a few
hours repofe at an inn, arranging each
part of his drefs with the utmoft preci-
fion, he fallied forth in the cool of the
evening, (for it was now the midft of
fummer) to deliver his recommendatory
letters.

letters. The firſt perſon to whoſe acquaintance he aſpired was Monſieur Baiſe-la-main, who occupied a ſumptuous hotel near the cathedral. Directing his ſteps to that quarter, he paſſed through ſeveral lanes and alleys with ſlowneſs and caution, and arrived in a ſpotleſs condition at the area of that celebrated edifice, which was enlivened by crouds of well dreſſed people paſſing and repaſſing each other, with many courteous bows and ſalutations, whilſt two ſets of chimes in the ſpire above them filled the air with ſober pſalmody. Waterſouchy was charmed when he found himſelf in this region of ſmirking faces, and ſtepping forwards amongſt them, enquired for Monſieur Baiſe-la-main. Every body pointed to a gentleman in a modiſh perruque, blue coat with gold frogs, and
black

black velvet breeches. To this prepof-
fefling perfonage he advanced with his
very beft bow, and delivered his letter.
No fooner did the gentleman arrange his
fpectacles, and glance over the firft lines
of the epiftle, than he returned the greet-
ing fourfold. Waterfouchy was as pro-
digal of falutations, and could ·hardly
believe his ears when they were faluted
with thefe flattering expreffions. "Your
arrival, Mr. Waterfouchy, is an event
I fhall always have the honour to re-
member. And, Sir, permit me to affure
you, from the bottom of my heart, that
nobody can feel more thoroughly the
obligations I have to my moft eftimable
friends at Amfterdam, for the opportu-
nity, Sir, they give me, of fhewing any
little, trifling, miferable attentions in my
power, to a difciple of Gerard Dow.

Let

Let me intreat you to tarry fome time
in my poor manfion : Indeed, Sir, you
muft not refufe me—I beg, my dear and
refpectable Sir,—I befeech"—It was im-
poffible to refift fuch a torrent of civi-
lity. Waterfouchy prepared to follow
the courteous banker, who, taking him
by the hand, led him, with every de-
monftration of kindnefs, to the door of
his hotel.

Its frontifpiece, rich with allegorical
figures, of which I never could obtain
a fatisfactory explanation, was diftin-
guifhed from more vulgar entrances, and
feats of coloured marble on each fide
added to its magnificence. Let my
readers figure to themfelves Monfieur
Baife-la-main, leading the obfequious
Waterfouchy thro' feveral large halls
and

and long paſſages, 'till they entered a rich apartment, where a circle of company, very ſplendidly attired, roſe up to receive them. Half an hour was ſpent in preſenting the artiſt to every individual. At length a pauſe in this ceremony enſued, and then the congratulations, with which he had been firſt received, were begun anew with redoubled ardour. Waterſouchy, finding himſelf ſurrounded by ſo many ſolemn ruffs and conſequential farthingales, was penetrated with the ſublimity of etiquette, and thought himſelf in the very Athens of politeneſs. This ſervice of rites and ceremonies, with which ſtrangers in thoſe times were uſhered into Antwerp, being hardly ended, the company began at length to relax into ſome degree of familiarity.

Mieris

Mieris and Sibylla Merian were now announced. Thefe two exquifite artifts had carried the minute delicacy of the pencil to the higheft pitch, and were pleafed with an opportunity of converfing with one of the moft promifing difciples of Gerard Dow. Our artift was equally happy in their fociety, and a converfation was accordingly fet on foot, in which Monf. Baife-le-main joining difplayed infinite knowledge and precifion. Having differted previoufly upon his own collection, this great patron of the arts led them into his interior cabinet, where Elfheimers, Rowland Saveries, Albert Durers, Brughels, and Polemburgs, collected at an immenfe expence, appeared on all fides. Mieris and Merian had alfo contributed to render it the moft complete in the Netherlands.

lands. Their performances entirely en-
groffed the choiceft corner in an apart-
ment, which a profufion of gilding and
carved work rendered fuperlatively fine.
The chimney-piece was encrufted with
the right old porcelain of China, and its
aperture, in this feafon, was clofed by a
capital *Pietâ* of Julio Romano, which
immediately ftruck Waterfouchy as an
eye fore. He detefted fuch coloffal re-
prefentations, fuch bold limbs and woe-
ful countenances : confcious they were
out of his reach, he condemned them as
out of nature. With fuch fentiments,
we may fuppofe he did not beftow much
attention on the *Pietâ*, but expatiated
with delight on the faithful reprefentation
of an apothecary's fhop by Mieris, and a
cupid, holding a garland of flowers, by
Merian. This ingerious lady was high
in

in his efteem. He adored the extreme nicety of her touch, and not a little admired that ftrict fenfe of propriety which had induced her to marriage ; for it feems fhe had chofen Jean Graff of Nuremburg for her hufband, merely to ftudy the *Nud* in a modeft way. After he had felicitated Madam Merian and Mieris upon their innumerable perfections, he took a curfory furvey of the reft of the collection. He commended Albert Durer; but could not help expreffing fome difcontent at Polemburg. The woody landfcapes, which this painter imagined with fo much happinefs, were in general interfperfed with the remains of antique temples, with rills and bathing nymphs in a ftyle our artift could never tafte. He liked their minutenefs, but condemned the choice of fubjects. " O ! " faid
Monfieur

Monſieur Baiſe-la-main, " I love Polem-
burg ; he is the eſſence of ſmoothneſs and
ſuavity. But I agree, that there is ſome-
thing rather confuſed and unintelligible
in his buildings, far unlike thoſe com-
fortable habitations which our friend
Mieris repreſents with ſuch meritorious
accuracy." Mieris bowed, and Water-
ſouchy, encouraged by Monſieur Baiſe-
la-main's coincidence with his opinion,
continued his critique. He ſhook his
head at a picture wherein Polemburg had
introduced a group of ruins, and ex-
claimed——" Why not ſubſtitute, for
example, the great church of Antwerp
flouriſhing in the height of its perfection,
in the room of thoſe Roman lumps of
confuſion and decay ?—Inſtead of repre-
ſenting the flowers of the parterre, he
crouds his foreground with all manner of
woods,

woods, and beſtows as much pains on a
dock leaf as I ſhould on the moſt eſti-
mable carnation in your garden. Naked
figures too I abhor: Madam Merian's
cupids excepted, they are unfit to be
viewed by the eye of decorum. And
what opportunities does an artiſt loſe by
the baniſhment of dreſs! In dreſs and
drapery are diſplayed the glory of his
pencil! In ear-rings and bracelets the
perfection of his touch—in a carpet all
his ſcience is united—grouping, colour-
ing, ſhading, effect, every thing! Po-
lemburg might have been a delightful
maſter, had he remained with us; but
he removed to Italy, and quitting the
manner of Elſheimer for the caprices of
Raphael, no wonder his taſte ſhould have
been corrupted." Monſieur Baiſe-la-
main and the artiſts liſtened attentively
to

to this harangue, and conceived great ideas of Waterfouchy's tafte and abilities. The banker thought himfelf poffeffed of the eighth wonder of the world, and from this moment refolved to engrofs it entirely.

Supper being ferved up, the company left the cabinet and entered a large hall, ornamented with the decollation of Holophernes by Mabufe, and a brawn's head by Mierhop.—In the midft appeared a table covered with dainties, in difhes of maffive plate, and illuminated by innumerable wax lights, around which the company was affembled. Waterfouchy was placed betwixt Monfieur Baife-la-main and the Burgomafter Van Gulph, a folemn upright man of glowing nofe and fair complexion. Our

U artift

artift could not for fome time take his eye
from off the Burgomafter's band, which
was edged with the fineft lace, and took
an opportunity, whilft the other guefts
were clofely engaged with the entertain-
ment, to make a fketch from it, that
did him honour and ferved to confirm
him in his patron's good opinion.

The repaft was conducted in the moft
orderly manner. By the time the Hip-
pocras and Canary wines were handed
about, univerfal fatiety and good hu-
mour prevailed. The little difappoint-
ments of thofe, who were too late for
one difh, or too full to tafte another,
were forgotten, and the refpectable Van
Gulph, having fwallowed his ufual
portion of the good things of this world,
began to expand, and pledged Water-
fouchy

fouchy with much affability, who loudly defcanted on the tafte and difcernment of Monfieur Baife-la-main, fo apparent in his rare collection. Mieris taking the hint, feconded the obfervation, which was enforced by Madam Merian, whofe example was followed by the reft of the ladies—Every one vied with his neigh-bour in fteeping fugar'd cakes in fweet wine, and beftowing the ampleft com-mendations on the cabinet of Monfieur Baife-la-main, who, in the midft of tranfport, exclaimed, " Now truly my pictures pay me intereft for my money!" The defert was ufhered in with profufion of applaufe: All was fmirk and compli-ment, whilft this fweetmeat was offered and that declined. At length it grew late, and the company feparated after the accuftomed formalities.—Waterfouchy

U 2 was

was conducted to his apartment, which
correfponded with the magnificence of
the manfion; and lulled afleep by the
moft flattering reflections, dreamt all the
night of nothing but of painting the
Burgomafter and his band. At breakfaft
next morning, he expreffed to Monfieur
Baife-la-main the ambition he had of dif-
tinguifhing himfelf at Antwerp, and
begged to feclude himfelf a fmall fpace
from the world, that he might purfue
his ftudies. Monfieur Baife-la-main ap-
proved of this idea, and affigned a room
for his reception, where he foon arranged
his pallet, pencils, &c. with all the pre-
cifion of Gerard Dow. Nobody but
the mafter of the houfe was allowed to
enter this fanctuary. Here our artift
remained fix weeks in grinding his co-
lours, compofing an admirable varnifh,
and

and preparing his canvafs, for a per-
formance he intended as his *chef d'oeuvre.*
A fortnight more paffed before he decid-
ed upon a fubject. At laft he deter-
mined to commemorate the opulence of
Monfieur Baife-la-main, by a perfpective
of his counting-houfe. He chofe an in-
terefting moment, when heaps of gold
lay glittering on the counter, and citizens
of diftinction were foliciting a fecure re-
pofitory for their plate and jewels. A
Mufcovite wrapped in fur, and an Italian
gliftening in brocade, occupied the fore-
ground. The eye glancing over thefe
figures highly finifhed, was directed thro'
the windows of the fhop into the area in
front of the cathedral; of which, how-
ever, nothing was difcovered, except two
fheds before its entrance, where feveral
barbers were reprefented at their different
occu-

occupations. An effect of funfhine upon the counter difcovered every coin that was fcattered upon its furface. On thefe the painter had beftowed fuch intenfe labour, that their very legends were diftinguifhable. It would be in vain to attempt conveying, by words, an idea adequate to this *chef d'oeuvre*, which muft have been feen to have been duly admired. In three months it was far advanced; during which time our artift employed his leifure hours in practifing jigs and minuets on the violin, and writing the firft chapter of Genefis on a watch paper, which he adorned with a miniature of Adam and Eve, fo exquifitely finifhed, that every ligament in their fig-leaves was vifible. This little *jeu d' efprit* he prefented to Madam Merian.

When

When the hour of publicly difplaying his great performance was drawing near, Monfieur Baife-la-main invited a felect party of connoiffeurs to a fplendid repaft, and after they had well feafted, all joined in extolling the picture as much as they had done the entertainment itfelf. Were I not afraid of fatiguing my readers more than I have done, I fhould repeat, word for word, the exuberant encomiums this mafter-piece received upon this occafion; but I truft it will be fully fufficient to fay, that none of the connoiffeurs were uninterefted, and every one had a pleafure in pointing out fome new perfection. The ladies were in extafies. The Burgomafter Van Gulph was fo charmed that he was refolved to have his portrait by this delicate hand, and Monfieur Baife-la-main immediately fettled a penfion

upon

upon the painter, merely to have the refufal of his pieces, paying largely at the fame time for thofe he took.

Thefe were the golden days of Water-fouchy, who, animated by fo much encouragement, was every week producing fome agreeable novel y. Attaching himfelf ftrongly to the manner of Mieris, he, if poffible, excelled him: his lillies were more gloffy, and his carnations fofter, and fo harmonious, that the Flemifh ladies, ever renowned for their frefh complexions, declared they had now found a painter worthy of portraying their beauty. Thus our happy artift, blown forwards by a continued gale of applaufe, reached a degree of merit unknown to his cotemporaries, and foon left Gerard Dow and Mieris behind him.

His

His pictures were eagerly fought after by the first collectors, and purchafed at fo extravagant a rate, that he refufed fketching a flipper, or defigning an ear-ring under the fum of *two hundred florins*. Every body defirous of poffeffing one of thefe treafures approached him with purfes of gold, and he was fo univerfally careffed and admired, that I (as a faithful biographer) am obliged to fay, he foon miftook his rank among the profeffors of the art, and grew intolerably vain.

Become thus confident, he embraced, without hefitation, the propofal of drawing the Burgomafter Van Gulph. All his fkill, all his minutenefs was exhaufted upon this occafion. The Burgomafter was prefented in his formalities, fitting in his magifterial chair: his band was not

X for-

forgotten ; it was finifhed to the fuper-
lative degree. The very hairs of his eye-
lafhes were numbered, and the pendent
carbuncle below his nofe, which had
baffled Mieris and the firft artifts, was at
length rendered with perfect exactitude
and fplendour. During the execution of
this incomparable portrait, he abfented
himfelf from Monfieur Baife-la-main,
and eftablifhed his abode at Van Gulph's,
whofe inflexible propriety furpaffed even
that of the banker. Waterfouchy, flat-
tered by the pomp and importance of
this great character, exclaimed, " You
are truly worthy to poffefs me!" The
Burgomafter's lady, who was a witnefs
to his matchlefs talents, foon expreffed
an ambition of being immortalized by
his pencil, and begged to be honoured
the next with his confideration. He
having

having almoſt determined never to un-
dertake another portrait after this *chef
d'oeuvre* of her conſort, with difficulty
confented.

At length he began: Ambitious of
ſhewing his great verſatility, and de-
firous of producing a contraſt to the
portrait juſt finiſhed, he determined to
put the lady in action. She was repre-
fented watering a capſacum, with an air
of fuperior dignity mingled with ineffable
fweetnefs. Every part of her drefs was
minutely attended to; her ruffle was ad-
mirable; but her hands and arms ex-
ceeded all idea. Gerard Dow had be-
ſtowed five days* labour on this part of
Madam Spiering's perſon, whoſe portrait
was one of his beſt performances. Wa-

terſouchy

* See Vies des Paintres Flamands, vol. 2. 217.

terfouchy, that he might furpafs his maf-
ter, fpent a month in giving only to his
patronefs's fingers the laft touch of per-
fection. Each had its ring, and fo tinted,
as almoft at firft fight to have deceived a
difcerning jeweller.

When he had finifhed this laft mafter-
piece, he found himfelf quite weak and
exhaufted. The profound ftudy in which
he had been abforbed, impaired his
health, and his having neglected exercife
for the two laft years brought on a hectic
and feverifh complaint. The only cir-
cumftance that now cheared his fpirits
was the converfation of a circle of old
ladies; the friends of Madame Gulph.
Thefe good people had ever fome little
incident to entertain him, fome goffip-
ing narration that foothed and unbended
his

his mind. But all their endeavours to restore him could not prevent his growing weaker and weaker. At last he took to cordials by their recommendation, became fond of news and tulips, and for a time was a little mended; so much indeed, that he resumed his pallet, and painted little-pieces for his kind comforters; such as a favourite dormouse for Madam Dozinburg, and a cheese in a China dish with mites in it for some other venerable lady, whose name has not descended to us. But these performances were not much relished by Monsieur Baise-la-main, who plainly saw in them the approaching extinction of his genius. One day at the Burgomaster's, he found him laid on a couch, and wheezing from under a brocade nightgown. " I have been troubled with an

asthma

afthma for fome time," faid the artift in a faint voice. " So I perceive," anfwered M. Baife-la-main. More of this interefting converfation has not been communicated to me, and I find an interval of three months in his memoirs, marked by no other occurrence than his painting a flea. After this laft effort of genius, his fight grew dim, his oppreffion increafed, he almoft fhrunk away to nothing, and in a few weeks dropped into his grave.

OLEANDER Language and Literature

Marvell's Allegorical Poetry
Bruce King
While Andrew Marvell's wit, sense of humour, finesse and sophisticated use of poetic convention have been increasingly admired in recent years, his poems are difficult to interpret, and even his subject-matter is occasionally obscure. Professor King's new book answers the central problems of Marvell criticism: what kind of poet was he, and what are his poems about?

A line-by-line reading of Marvell's best-known lyrics reveals unity of vision in what were formerly considered to be a miscellaneous collection of poems. Marvell is shown to be a religious poet using allegorical techniques to imply meaning and secular themes to offer a sacramental vision of the universe.

Besides interpretations of *The Garden* and *To his Coy Mistress* the book includes studies of such neglected poems as *The Unfortunate Lover* and *Musicks Empire.*

Marvell's Allegorical Poetry is based on scholarship and the detailed interpretation of poetry, but is written for the student and general reader. The discussion of sources and of previous criticism is kept to a minimum; the emphasis is on the reading of individual poems. The work is an important and probably controversial contribution to the understanding of 17th-century poetry. 1977.
Cloth $8.95 ISBN 0 902675 60 5 £3.75

Just Pick a Murricane?
By N.E. Chantz
When an author conjugates the present tense of the verb 'to have' as 'zgami, zgatcha, zgadim, zgadders, zgatchall, zgadum', we need not ask 'Just Pick a Murricane?' since he clearly cairn and does. Here is a trains alanic lexicon, defining such ziparoos as *beadle eyeded, cankered, dennis, Euston, foam, Gladicea,* and all the joyous rest.
"Ticklingly funny" — *Northern Echo.*
Paper $1.25 ISBN 0 902675 11 7 30p

Aristotle's Mother
Sir Herbert Read
Written as a radio play for the BBC, this imaginary conversation is here
separately published for the first time. A distinguished work in a medium otherwise ephemeral. Uniform with *Lord Byron at the Opera.*
Paper $1.25 ISBN 0 900891 03 3 52p

A Dictionary of Common Fallacies
Philip Ward
Over five hundred popular errors are defused, if not definitively exploded, in an objective reference work that investigates false notions
in medicine, science, religion, history, food fads, and much else. 1977.
Cloth $9.50 ISBN 0 900891 14 9 £4.00

Television Plays
Philip Ward
Hawklaw concerns the peculiar ménage of a famous artist who has
every reason to keep even his warmest admirers at a distance. In *A
Fence round the Property,* two brothers are obsessed by the past but
differ (perhaps) on their attitude to the future. Excellent examples of
the use of television in two contrasting styles.
Paper $3.25 ISBN 0 902675 45 1 90p

The Quell-Finger Dialogues
These imaginary dialogues, distilling the philosophy and world view of
the polymath Jakob Hessel Finger in terse conversations with Evenyn
Quell, are now known to be based on the thought of Reinhold Regensburger, founding president of the Private Libraries Association, who
died in December 1972. Privately printed in homage to Dr. Regensburger's memory.
Paper $1.25 ISBN 0 900891 01 7 52p

The Hidden Music
Östen Sjöstrand
The leading contemporary Swedish poet is here made available in English for the first time, with translations by Robin Fulton and critical material assembled by Staffan Bergsten.
Paper $4.00 ISBN 0 902675 35 4 £1.25

A Maltese Boyhood
Philip Ward
A new collection of stories including *Maze* (from *Transatlantic Review*) and other fiction written since the collection *A Lizard* (1969), mostly previously unpublished.
Paper $4.00 ISBN 0 902675 41 9 £1.25

Romagnol: Language and Literature
Douglas B. Gregor
First interested by the regional language's phonetics, and later excited by the poetry which has raised Romagnol to a position in the front rank of Italian languages, D.B. Gregor now presents the first systematic grammar, with a representative anthology of prose and poetry in Romagnol, with facing translations of great verve and accuracy.
Paper $13.50 ISBN 0 902675 12 £4.00

Mad Nap: 'Pulon Matt'
Douglas B. Gregor (translator)
A companion to *Romagnol, Mad Nap* is the poetic masterpiece of Romagna, that region of Italy encompassing Ravenna, Rimini, Cesena, Forlì and Faenza. A modern edition of the text, with a translation into modern Italian, and another into English verse.
Paper $13.50 ISBN 0 902675 37 0 £4.00

Indonesian Traditional Poetry
Philip Ward
The first English-language anthology of annotated texts from Indonesian folk verse (Javanese, Tolaki, Minangkabau, Ngaju Dayak and many more) with translations and a linking socio-religious commentary.
Paper $13.50 ISBN 0 902675 49 4 £4.00

The Art and Poetry of Ramuz
David Bevan
The twentieth-century Swiss novelist Charles-Ferdinand Ramuz has long been neglected in Anglo-Saxon literary criticism. By some critics he has been rejected because of the peculiarities of a style which Claudel and very few others considered among the most remarkable in all French literature. By others he has been dismissed unfairly as a regional novelist.
Yet today it can be seen that Ramuz's rich, original narrative clearly prefigures many features of the *nouveau roman,* although his transparent faith in the eternal greatness of Man, despite two recent wars, can be interpreted as a message of hope. The first major work on Ramuz in English, by David Bevan of the University of Port Elizabeth, establishes the Swiss novelist as one of the most significant literary figures of our century. It demonstrates how Ramuz achieves in his fiction a close interrelation between his message and his style, finding in his best work the full internal coherence characteristic of great art. 1977.
Casebound $4.00 ISBN 0 902675 47 8 £1.20

Friulan: Language and Literature
Douglas B. Gregor
The first English-language grammar of the Friulan language of northeast Italy is accompanied by an anthology of the most important poems and prose texts to be written in Friulan, with facing English translations by the author.
Paper $15.00 ISBN 0 902675 39 7 £5.00

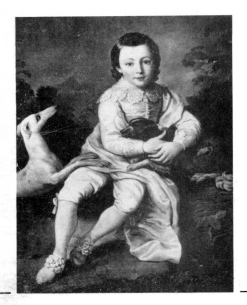

WILLIAM BECKFORD (1760-1844) is one of the great English eccentrics. Left a millionaire by his father at the age of eleven, he inherited a magnificent art gallery and was later to buy Gibbon's private library in Switzerland.

A refined connoisseur of wit and elegance, he wrote little but well, usually obliquely. *Vathek: an Arabian tale* (1786) has secured Beckford's page in literary history, but his other works are equally remarkable. They include *Dreams, waking thoughts, and incidents* (1783; revised in 1834), and *Recollections of an excursion to the monasteries of Alcobaça and Batalha* (1835). The *Biographical Memoirs of Extraordinary Painters,* completed at the age of nineteen, is a puzzling work of intermittent brilliance and pervasive complexity. In his introduction, Philip Ward takes account of recent scholarship, in particular the contributions of André Parreaux, to enable the modern reader to obtain the greatest possible value from the first facsimile reprint of the book since William Beckford's death.